SOME AESTHETIC DECISIONS

SOME AESTHETIC DECISIONS

THE PHOTOGRAPHS OF JUDY FISKIN

VIRGINIA HECKERT

WITH AN INTERVIEW BY JOHN DIVOLA

THE J. PAUL GETTY MUSEUM | LOS ANGELES

Published by the J. Paul Getty Museum, Los Angeles
Getty Publications
1200 Getty Center Drive, Suite 500
Los Angeles, California 90049-1682
www.gettypublications.org

Dinah Berland, *Editor*
Catherine Lorenz, *Designer*
Anita Keys, *Production Coordinator*

Printed in China

Library of Congress Cataloging-in-Publication Data

Heckert, Virginia.
 Some aesthetic decisions : the photographs of Judy Fiskin / Virginia Heckert ; with an interview by John Divola. — 1st ed.
 p. cm.
 Summary: "A monograph of the work of Los Angeles–based artist Judy Fiskin. Includes duotone reproductions of 288 photographs made by Fiskin from 1973 to 1995, as well as an introduction, an interview with the artist, a chronology, and a bibliography"— Provided by publisher.
 Includes bibliographical references.
 ISBN 978-1-60606-081-0 (hardback)
1. Architectural photography—California. 2. Landscape photography—California. 3. Architectural photography—United States. 4. Fiskin, Judy. I. Fiskin, Judy. II. Divola, John. III. J. Paul Getty Museum. IV. Title.
 TR659.H426 2011
 779'.3609794—dc22
 2011011297

CONTENTS

FOREWORD

Judy Fiskin is a quintessential Los Angeles artist, having spent her childhood in L.A., studied at California institutions, and taught photography on the faculty of the California Institute of the Arts since 1977. She has created a body of photographic work that offers both an intimate knowledge of the visual fabric of this diverse, sprawling city and a distinctive way of communicating it. Her series of images of the vernacular architecture of Southern California, with its stucco houses and boxlike, midcentury apartment buildings, have become emblems of times past. They also epitomize the yearning for a brighter future that is so characteristic of the postwar environment in which Fiskin came of age as an artist.

During the process of proposing an acquisition of Fiskin's photographs for the J. Paul Getty Museum's collection, Virginia Heckert, curator of photographs and herself a Los Angeles native, learned that Fiskin had begun to edit down all the images she had made between 1973 and 1995. This publication, with its 288 images arranged in fourteen series, is the result of that editing process and represents the artist's complete photographic oeuvre in still photography. Her artistic practice continues in the medium of video.

I would like to offer my appreciation to Judy Fiskin for allowing us to create this definitive record of her photographs, and to Virginia Heckert for working with the artist to organize this volume and for contextualizing the work in her introductory essay. We are grateful to the staff of Getty Publications and Getty Imaging Services for their professional expertise in so closely conveying the aura of Fiskin's miniature, gelatin silver prints. Although small in size, these images encompass the vastness of Los Angeles.

Some Aesthetic Decisions: The Photographs of Judy Fiskin is published in conjunction with the photography exhibition *In Focus: Los Angeles, 1945–1980*, on view at the J. Paul Getty Museum from December 20, 2011, to May 6, 2012. The photographers in this exhibit, including Fiskin, represent a most fertile and exciting period in Los Angeles when contemporary photography in its many forms began to be recognized as a fine art. The *In Focus* show joins a series of exhibitions and events taking place between October 2011 and March 2012 under the umbrella of Pacific Standard Time, an initiative of the Getty Foundation and Getty Research Institute that celebrates the postwar art and architecture of Southern California.

The Department of Photographs seeks to collect and preserve the work not only of pioneers of the medium but also of artists in our midst. We are especially pleased, therefore, to be able to offer this record of Judy Fiskin's photographic work, which speaks with such an individual voice about the curious and ever-surprising environment of Los Angeles.

Judith Keller, Senior Curator
Department of Photographs, J. Paul Getty Museum

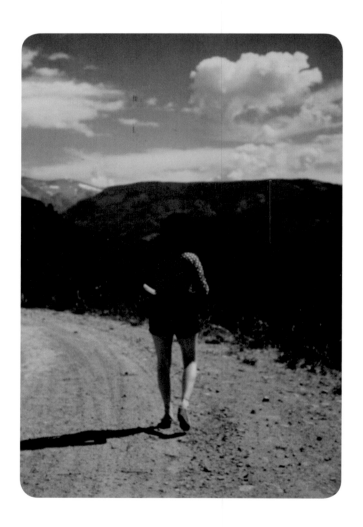

FIGURE 1

Judy Fiskin photographing in the desert, 1976. Courtesy of Judy Fiskin

JUDY FISKIN'S AESTHETIC DECISIONS

VIRGINIA HECKERT

Taking a position somewhere between Edward Weston's technique of previsualization and Garry Winogrand's desire to see what things look like when photographed, Judy Fiskin has said that the most interesting aspect of being a photographer is "looking at this little universe of representation that I can make out of the world."[1] Though Fiskin was motivated by curiosity for each of her subjects, which range from vernacular architecture to flower-arranging competitions, her interest while working in the medium of photography over the course of twenty-five years was ultimately less in the subject itself than in how it would look when photographed. She was also interested in beauty—in the sense not of finding beautiful objects to photograph but of creating beautiful photographs from the objects she excerpted from the world. She has described her use of the phrase "aesthetic choice" as a metaphor for the arbitrary nature of choices that are made in the creation and critique of art and architecture, her primary subjects.[2] Although it was not until she applied the title Some Aesthetic Decisions to one of her series that she drew explicit attention to this concept, Fiskin has continuously focused on the arbitrariness of choice while at the same time being deliberately decisive in her own choices.

Beginning in 2004, approximately a decade after health problems led her to shift her attention from photography to video, Fiskin began to revisit, edit, and compile the complete body of her photographic oeuvre, the result of which is represented in this volume. Not coincidentally, Fiskin did this while reviewing work for inclusion in exhibitions with her new commercial gallery and also working on the video The End of Photography. Shot with a handheld Super 8 camera and running just under 2½ minutes, the video laments the inevitable loss of photography in an increasingly digital world. As the camera lingers for a few seconds at a time on unremarkable details of residen-

tial architecture and landscaping, a female voice enumerates the darkroom equipment that will no longer be needed: "No more film, no more canisters, no more reels, no more tanks . . . ," finally arriving at "no more photography." The title refers equally to the shift from analog to digital photography, to the disappearance of the vernacular landscape of Los Angeles that Fiskin had photographed in previous decades, and to the end of Fiskin's own practice as an artist-photographer, which spanned the years 1973 to 1995.

Fiskin's photographs are distinguished by several characteristics, which can be organized into the categories of content and of form. With respect to the first, Fiskin used a serial approach to vernacular subjects that she selected from fields of aesthetic interest such as architecture and design, deliberately avoiding those examples associated with the highest standards of style or taste.[3] Rather than centering on Southern California's iconic civic architecture, for instance, Fiskin's interests revolved around the mundane stucco bungalows of Hollywood, West Hollywood, and Atwater Village (Stucco, 1973–1976); residential and commercial buildings in the city of San Bernardino (35 Views of San Bernardino, 1974); rows of Quonset huts, storage containers, and officers' barracks on military bases (Military Architecture, 1975); structures associated with the harbor, oil, and railroad industries of Long Beach, as well as its now-defunct amusement park, the "Pike" (Long Beach, 1980); and—perhaps most memorably—the two-story apartment buildings that sprang up along the Southland's freeways in the late 1950s and '60s (Dingbat, 1982–1983). Her last series of architectural images features single-family residences in various cities throughout Los Angeles, Orange, and Ventura Counties, including Huntington Beach, San Pedro, and Westminster (New Architecture, 1988). Fiskin's interest in decorative and other domestic arts led to photographic

essays on flower and home shows (Some Aesthetic Decisions, 1983–1984); seventeenth- and eighteenth-century furnishings and period rooms in both historic houses and museum collections, including that of the J. Paul Getty Museum (Portraits of Furniture, 1988); submissions to county fairs and arts-and-crafts fairs (Some Art, 1990); and reproductions of works of art from encyclopedias and other reference books (More Art, 1992–1995). Even forays outside of Southern California produced depictions of single-family residences and duplexes, as in New York City's outer boroughs of the Bronx, Brooklyn, Queens, and Staten Island (My Trip to New York, 1984–1986); funerary monuments (New Orleans, 1985); or seaside homes along the Atlantic (Jersey Shore, 1985–1988). The one series she dedicated to the landscape features not majestic mountains and towering trees but the flat barren desert, its endless roads, and comical cacti and Joshua trees (Desert, 1976; fig. 1).

The second category, that of form, refers to the physical characteristics of Fiskin's photographs. Her diminutive images measure approximately 1¾ x 2¾ inches, or 2½ inches square, and are rendered in black and white, framed by the edges of the negative, centered on a sheet of paper that is trimmed to 8 x 5¾ inches, and contained within a specially designed white or black wood frame measuring approximately 10½ x 8 inches. Over the course of the two and a half decades during which she created the photographs included in this book, this format remained fairly consistent. Although sometimes mistaken for contact images, the prints in fact represent enlargements from 35 mm negatives, vertically or horizontally oriented in the earliest series but altered beginning in 1978 to a square format resembling 2¼ inch negatives when she had metal flanges attached to the shutter plane of her camera. Fiskin's decisions to drop the enlarger down to its lowest position, to include the edges of the negative and thereby avoid having to make choices related to cropping, and to consider the white ground of the larger sheet of photographic paper as well as the frame as integral to the finished work, transformed her images into small sculptures.[4] While her photographs initially seem to invite sustained, intimate viewing, Fiskin's choices related to camera, film, paper, and developing and enlargement techniques in the darkroom ultimately frustrate our ability to come close enough. As discussed in greater detail later, it is this "push-pull" effect within Fiskin's work that defines it at its most fundamental level.

Born in Chicago in 1945—on April 1 (April Fool's Day), which undoubtedly helped shape her droll sense of humor—

Fiskin grew up in Los Angeles, where, she recalls, she was a happy child but an alienated teenager.[5] Her father, a stockbroker, and her mother, a homemaker with a degree in art history from the University of Chicago, encouraged their daughter's creative impulses, which included storytelling, writing, and playacting family dramas in an elaborate dollhouse. Fiskin entered college at age seventeen, studying art history at Pomona College in Claremont. She spent her junior year abroad in Paris, where once-weekly lectures at the Sorbonne's Institute of Art and Archaeology left plenty of time for travel throughout France to view medieval architecture and sculpture in situ. Her preference for the squat, heavy proportions of Romanesque art, rather than the soaring towers of Gothic cathedrals, foreshadowed her interest in the vernacular architecture and arts to which she would later turn her attention as a photographer.

After graduating with a bachelor of arts degree in 1966, Fiskin moved to northern California, where she entered the graduate program in art history at the University of California, Berkeley, and her fiancé (whom she would marry in early 1967) entered the MFA program in art. Upon realizing that the study of art history at the graduate level was less about appreciation and discovery than memorization and classification by date and style, Fiskin quit the program—until faced with the reality that her most promising employment prospects were as a typist.[6] She reenrolled at the university and in 1967, after her husband completed his MFA degree, moved back to Los Angeles, where she continued her studies at the University of California, Los Angeles. Courses with the art historian Kurt von Meier introduced her to unconventional ways of looking at and thinking about art; an assignment to document iconographic symbols in the environment with a camera led to a moment of self-discovery. Despite her previous beliefs to the contrary, it was possible for her to become an artist—not via drawing, painting, or sculpture, for which she had never felt she possessed sufficient manual dexterity or hand-eye coordination, but via photography, which synthesized the two things she had initially loved in her study of art history: the acts of looking and discovering.

Fiskin completed her master's degree in art history in 1969 and immediately shifted her focus to photography, experimenting in her brother-in-law's darkroom, taking a summer school course with Edmund Teske at UCLA and later a course at Art Center College of Design in Pasadena. For the most part, however, she taught herself, working briefly with a 4 x 5 inch camera

before returning to her 35 mm camera. Though she had never done so before that assignment with von Meier, framing the world through the viewfinder of a camera felt comfortable, even familiar, reminiscent as it perhaps was of studying reproductions of works of art in books and slide lectures.

Fiskin was invited to participate in her first group exhibition in 1972, at California State University, Los Angeles, and had her first solo shows in 1975, exhibiting her San Bernardino series at California State University, San Bernardino, and Pitzer College, Claremont, and her Military Architecture series at the University of California, Irvine. In the ensuing thirty-five years, her photographs have been exhibited in well over one hundred gallery and museum shows, both nationally and internationally (see the chronology at the back of this volume). Notable solo exhibitions and projects include the debut of her desert photographs at Castelli Graphics, New York, in 1976; a 1979 commission to create a body of work for the Art Museum and Galleries of California State University, Long Beach, with funding from the National Endowment for the Arts and the California Arts Council; and the presentation of twenty years of photographs at the Los Angeles Museum of Contemporary Art in 1992, an exhibition accompanied by the artist's book *Some More Art*. Group exhibitions that have featured her work have tended to emphasize typological or other collection-related approaches to the photographic medium, art conceived on a small scale, or art that has helped to shape the image and identity of Los Angeles.[7]

The influence of Fiskin's art history studies on her photographs has often been a topic of discussion in the presentation or review of many of these exhibitions, and Fiskin acknowledges that her academic background helped inform her photographic practice.[8] It is certainly evident that the size of her images recalls that of the 35 mm slides used in art history lectures, that the consistent size of her images encourages didactic side-by-side comparisons within each series and across series, and that the inventory of objects within each series creates a comprehensive lesson demonstrating the range of styles for a particular subject. Fiskin also identifies other influences that led to her predilection for small-scale images; among these are the dollhouse she played with as a child and the miniatures, along with other works of art, that her mother collected in their home.

Additionally, Fiskin believes that her upbringing in Los Angeles inspired her interest in the vernacular. At least two series, Stucco (plates 1–21) and Dingbat (plates 96–137), grew out of her curiosity regarding residential structures that, while considerably different from the homes in her family's upper-middle-class Westside neighborhood, nonetheless possessed their own distinct characteristics and charm. Two other series, 35 Views of San Bernardino (plates 22–35) and Desert (plates 52–78), recall childhood memories of driving through these areas to arrive at family vacation destinations in Palm Springs or Las Vegas. Even if she had not been commissioned by the Art Museum and Galleries of California State University, Long Beach, to create a series of Long Beach photographs (plates 79–95), her desire to explore Southern California locales farther afield might have led to a similar body of work. To some extent the series Military Architecture (plates 36–51) did grow out of this desire; spurred initially by her perusal of Keith Mallory and Arvid Ottar's book *The Architecture of War*, she was further motivated by the challenge of gaining permission to photograph military sites that extended from Ventura County to San Diego County.[9]

Fiskin recognized that she was creating a catalogue of vernacular architecture, which suggests the influence of two photographers whom she greatly admired: Eugène Atget, who photographed Paris and its environs in the late nineteenth and early twentieth centuries, and Walker Evans, whose documentation of the American South during the Depression included images of small towns and commonplace structures. More specifically, however, she was thinking about Southern California and what it meant to live there. Several publications that attempted to describe, even celebrate, the unique character of Los Angeles from a variety of points of view provided other sources of inspiration; among these were the writings of Joan Didion and Raymond Chandler, as well as the inexpensively produced photographic picture books that Ed Ruscha self-published in the early 1960s and '70s.

Although Fiskin read about Maria Wyeth, the protagonist actress on a downward spiral in Didion's *Play It as It Lays*, who traverses the freeways of Southern California to gain a sense of control, and also about the fretting babies and sulking maids in Didion's essay "Los Angeles Notebook," none of these characters found their way into her photographs, which are devoid of people.[10] Rather, what appealed to Fiskin was the mood of bleakness, which the wide expanses and seemingly endless roads in her Desert photographs capture so succinctly (plates 52–78). (Fiskin's account of reading survival books in advance of photographing in the desert and learning how to burn her car's tires to

signal for help or the importance of traveling with a snakebite kit becomes unexpectedly humorous when one sees the "survival attire" she donned for these outings (see fig. 1).[11] The closest thing to an anecdotal representation in Fiskin's photographs is the blurred car in the foreground of an image from the San Bernardino series. The car might very well have been driven by one of the meek wives Chandler described in his short story "Red Wind," women who ran their fingers along the edges of their carving knives and studied their husbands' necks when the Santa Ana winds blew (plate 23).[12] Like Chandler's detective stories, novels, and screenplays, Fiskin's photographs capture the ambiance of Los Angeles and its architecture as if the city itself were a character.

The publication that perhaps most influenced Fiskin was architectural critic Reyner Banham's 1971 book *Los Angeles: The Architecture of Four Ecologies*.[13] Born and educated in England, Banham became an Angeleno at heart when he visited Los Angeles in 1965. His book was instrumental in putting into perspective how the city's architecture responded to its ecologies of beach ("Surfurbia"), mountains (the "foothills"), flatlands (the "plains of Id"), and freeways ("Autopia"). As one of many artists and architects who responded to Banham's designations of ecologies and built environments, Fiskin undoubtedly gained the confidence from Banham's work to photograph several of the building types to which she was already naturally drawn. Most notable among these was the dingbat, which Banham described as "the current minimal form of multi-family residential unit" that was "normally a two storey walk-up apartment-block developed back over the full depth of the site, built of wood and stuccoed over." Banham went on to describe the buildings from the street: "But out the front, dingbats cannot be left to their own devices; the front is a commercial pitch and a statement about the culture of individualism. A row of dingbats with standardized neat backs and sides will have every street façade competitively individual. . . . Everything is there from Tacoburger Aztec to Wavy-line Moderne, from Cod Cape Cod to unsupported Jaoul vaults, from Gourmet Mansardic to Polynesian Gabled and even—in extremity—Modern Architecture."[14] One would be hard-pressed to find more compelling—or appealing—visual accompaniment for Banham's descriptions than the photographs in Fiskin's Dingbat series (plates 96–137).

Instilled in these photographs is a sense of humor that stems as much from the term *dingbat* (and its anthropomorphic associations with both *ding-a-ling* and *batty*) as from the distinct care with which Fiskin framed these facades, each one slightly quirkier than the last. Her deadpan approach has much in common with that found in Ruscha's artist's books, several of which feature sequences of nondescript commercial and residential structures, among them gas stations, parking lots, and apartment buildings (fig. 2).[15] Ruscha's books provided affirmation for Fiskin and many other photographers who were looking at similar structures that a minimal, no-frills approach could produce powerful results.

Curator William Jenkins also recognized the power of this strategy when he posited an obvious visual link between the rigorous purity and deadpan humor found in Ruscha's photographs, as well as their ability to convey "substantial amounts of visual information but [eschew] entirely the aspects of beauty, emotion, and opinion," and the work of a number of contemporary photographers who similarly turned their cameras to vernacular architecture in the early 1970s.[16] Among the photographers he included in the exhibition *New Topographics: Photographs of a Man-Altered Landscape*, which he organized for the International Museum of Photography at George Eastman House in Rochester, New York, in 1975, were three who depicted Southern California subjects at that time or during the period immediately thereafter: Lewis Baltz, Henry Wessel Jr., and Joe Deal.[17] Jenkins noted the minimal influence or inflection imposed by the exhibition's photographers on the look of his or her respective subject matter, describing their approach as "anthropological rather than critical, scientific rather than artistic."[18]

Fiskin's work might also have been included in *New Topographics* (Jenkins sent Baltz to view her photographs on his behalf) but ultimately was not. It is worth noting, however, that many similarities exist between her work and that of the photographers in the exhibition. For example, despite the assertion that the *New Topographics* images were neutral, many of the photographers in the exhibition in fact used specific aesthetic strategies to create a distinct style. For Baltz it was positioning parallel to the picture plane the industrial-park facades he photographed near Irvine, California (fig. 3); for Wessel it was the framing of palm trees, streetlamps, and sidewalks to punctuate commercial and residential neighborhoods in Los Angeles (fig. 4); and for Deal it was choosing an elevated point of view from which to photograph burgeoning suburban housing developments so that the horizon line was eliminated (fig. 5).

Many of the *New Topographics* photographers also emphasized the production of technically beautiful prints,

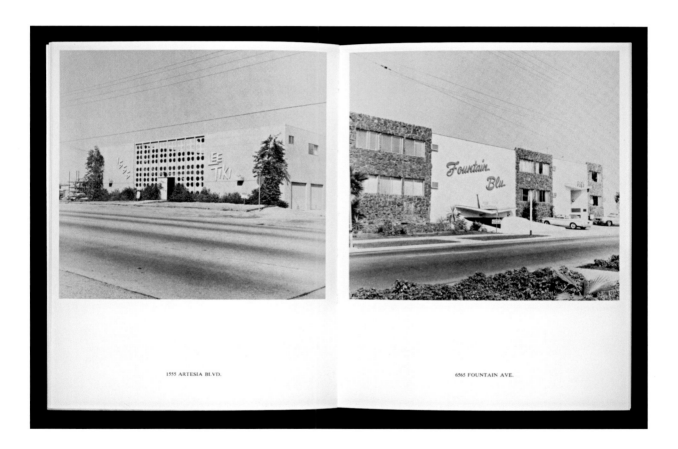

1555 ARTESIA BLVD.

6565 FOUNTAIN AVE.

FIGURE 2

Ed Ruscha (American, b. 1937), double-page spread from *Some Los Angeles Apartments* (Los Angeles, 1965). Special Collections, Getty Research Institute, N7433.4.R951 S66 1965. © Ed Ruscha

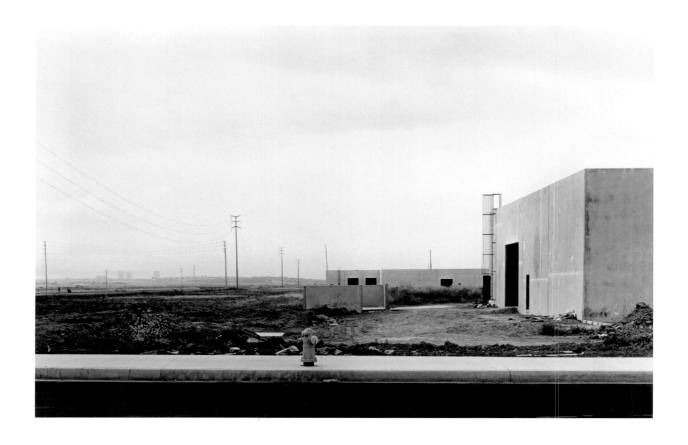

FIGURE 3

Lewis Baltz (American, b. 1945), *New Industrial Park* (*IP 28*), 1974. Gelatin silver print, 15.2 × 22.9 cm (6 × 9 in.). Gift of Professors Joseph and Elaine Monsen. Los Angeles, J. Paul Getty Museum, 92.XM.55.1. © Lewis Baltz

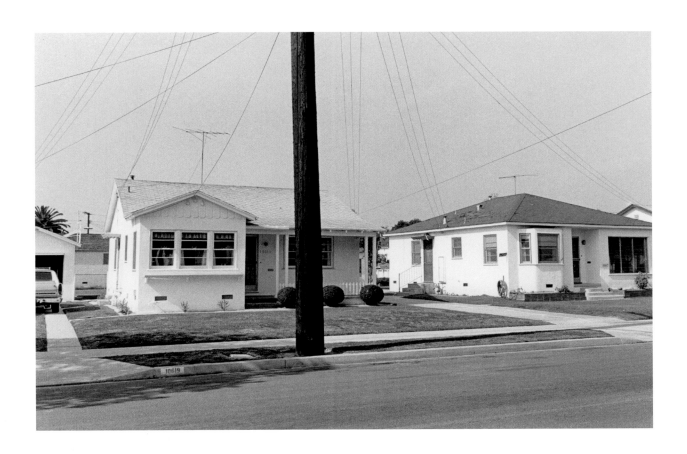

FIGURE 4

Henry Wessel Jr. (American, b. 1942), *Los Angeles*, 1971. Gelatin silver
print, 20.2 × 30.2 cm (7¹⁵⁄₁₆ × 11⅞ in.). Purchased with funds provided
by the Photographs Council of the J. Paul Getty Museum. Los Angeles,
J. Paul Getty Museum, 2007.18.1. © Henry Wessel Jr.

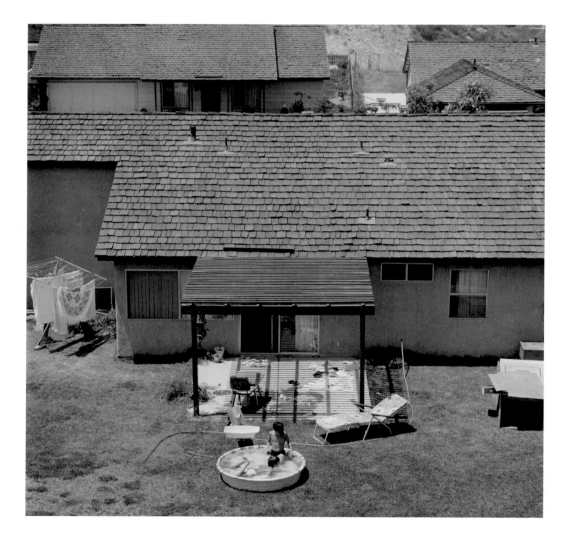

FIGURE 5

Joe Deal (American, 1947–2010), *Backyard, Diamond Bar, California,*

1980. Gelatin silver print, 28.4 × 28.7 cm (11³⁄₁₆ × 11⁵⁄₁₆ in.). Los Angeles,

J. Paul Getty Museum, 2008.57.8. © Estate of Joe Deal

another feature at odds with the neutrality Jenkins ascribed to their work. Curator Matthew S. Witkovsky has recently argued that the "objecthood" of Baltz's Prototype works of 1967–73 "undoes their status as views of any sort onto reality—alternative, true, ironic, or otherwise."[19] After discussing "the peculiar qualities of constructedness, perspectival flattening, unnatural lustre and strategically diminished information" that result from Baltz's handling of camera, negative, and print, Witkovsky focuses on the particularities of printing and mounting: Baltz mounted the trimmed photograph to another sheet of processed photographic paper trimmed to the same size, then glued the paired sheets to a warm mat board to create a "super-subtle raising of the picture plane" that emphasizes the identity of the Prototype photographs as things rather than images.[20] In a very similar way, Fiskin's handling of camera, negative, and print emphasizes the objecthood of her photographs. She initially presented her work—printed as it was on a sheet of paper trimmed to 8 x 5¾ inches, which thereby created a flush mount of exactly the same white within the image—in a Plexiglas box frame. Over the course of her 1984–86 stay in New York, she worked with a sculptor to design the stepped wooden frame that is an integral component of the finished work.

In her 1988 interview with John Divola (see pages 15–21, herein), Fiskin discusses the qualities that she believes ultimately differentiate her images from those of both Ruscha and the New Topographic photographers. Making no pretense about adopting a neutral attitude, she suggests that it was precisely her desire to inject the emotional states of depression, bleakness, and arbitrariness into her work that sets it apart.[21] A few years earlier, critic John Brumfield had observed: "For Ms. Fiskin, the camera is a recording device whose record is of value precisely because it is susceptible of aesthetic information. And that transformation is a calculated product of the artist's vision. The image is not a dispassionate document, but an invention; not an objective invention or a universal truth, but a subjectively personal fabrication."[22] Although Jenkins summarized the premise of New Topographics as the proposal of "what it means to make a documentary photograph," Fiskin, taking her cue from Walker Evans, always understood documentary photography to be a style, not a position of neutrality.[23] Further, Fiskin's work does not live up to the interpretation of New Topographics photographs by art historians such as Jonathan Green, who referred to them as a commentary on the conflict between man and nature in the second half of the twentieth century.[24] Fiskin was less interested in commenting on the way in which the landscape had been altered by man-made structures than on issues of taste or style and how these change over time.

Fiskin lived in New York from 1984 to 1986, when both she and her second husband, the historian and journalist Jon Wiener, took leaves of absence from their respective teaching positions, Fiskin's at the California Institute of the Arts and Wiener's at the University of California, Irvine. During this period, she created the largest series of her career, My Trip to New York, which contains forty-six images (plates 166–211). She also made photographs during a trip to New Orleans, printing them as a small series in 2006 (plates 212–216). She returned to New York for six months from September 1988 to March 1989, during which time she completed the smallest series of her career, Jersey Shore, comprising just three images, the first of which (plate 217) was made at the end of her earlier stay in New York.

For the most part, however, it is those series that are no longer dedicated to the built environment that most fully reveal the leitmotif that runs through Fiskin's oeuvre.[25] Some Aesthetic Decisions (1983–1984), Portraits of Furniture (1988), Some Art (1990), and More Art (1992–1995) address issues of taste head-on; they can also be seen as the starting point for the videos she began to make in the late 1990s.

The majority of the photographs in Some Aesthetic Decisions (plates 138–165) depict floral arrangements on display in flower shows, home shows, county fairs, and private homes. Fiskin was intrigued by the static, outdated aesthetic that shaped the practice of flower arranging, the seriousness with which practitioners adhered to its rules, and the paradigm it suggested for how women of her mother's generation and social status felt they could comfortably engage in the arts at that time. In her interview with Divola, Fiskin all but admits how much their reality frightened her.[26] She embraced the challenge of trying to create compelling photographs from displays in the categories of dried materials or bonsai, even though these arrangements were often awkward or stiff or felt foreign to her. The resulting photographs do not bear judgment; they simply present the arbitrariness of taste as it comes into and goes out of fashion. Fiskin also intended for these photographs to convey her realization that issues of taste are enforced and conveyed by a matriarchal voice, that taste is intrinsically enmeshed with class, and that taste can be used to maintain or achieve class status.

For the series Some Art (plates 251–269) Fiskin photographed existing works of art, visiting county fairs, arts-and-crafts fairs, and friends' homes. For the series More Art (plates 270–288) she photographed reproductions of works of art, poring through reference books in libraries. Both of these series revolve around the arts, but with a very catholic sensibility that places amateur paintings, wood carvings, and needlepoint side by side with etched glass lamps, Wedgwood plates, and nineteenth-century mosaics. In reviewing Fiskin's first presentation of Some Art in her Los Angeles and New York galleries, critic Terry R. Myers referred to Fiskin's "effortless intermingling of high and low, art and craft, known and anonymous."[27]

Other artists were engaged in similar pursuits, most notably Richard Prince, who appropriated existing images from advertising photography, and Sherrie Levine, who rephotographed quintessential works by Walker Evans, Edward Weston, and Karl Blossfeldt from exhibition catalogs. Fiskin's practice, however, never fully entered into the Postmodern context of the work of these and other artists, both because she was not photographing photographs and because of the relative obscurity or humble character of her source material. Additionally, hers continued to be a commentary on taste and style, not on the act of authorship. Like the floral arrangements she photographed, her images draw our attention to the ways in which individuals attempt to create something beautiful, unique, or memorable, and the fact that our responses to those creations change over time.

When Fiskin noticed that many of the reproductions she was photographing for the series More Art depicted objects that were either dark or enigmatic in character or that addressed the subject of death, she realized that another dimension suffused this work. It was at this time that her father died and that she also realized she would no longer be able to make photographs. Fiskin's health began to suffer from complications related to an autoimmune disorder in the mid-1990s, which made it difficult for her to be on her feet for long periods, particularly in the darkroom.

Each of Fiskin's series contains a different number of photographs, ranging from forty-six in My Trip to New York to just three in Jersey Shore. The final numbers are not arbitrary; they are the result, on the one hand, of Fiskin's effort to complete each series for exhibition and, on the other, of the rigorous editing process she implemented throughout her practice and began to finalize in 2004. For example, the 1974 series that she originally exhibited and published as Thirty-One Views of San Bernardino

is represented by just fourteen images in this publication (plates 22–35), even though she has referred to it for several years in terms of "thirty-five views."[28] Fiskin's willful introduction of this element of uncertainty underscores the extent to which the publication of her oeuvre now serves to finalize her editing process.[29] Taking into account her self-assigned task of shooting three rolls of film each week—tallying roughly just over 100 exposures a week, 5,000 exposures a year, and potentially 100,000 exposures over the course of two and a half decades—the 288 photographs reproduced in this publication reveal just how exacting Fiskin was in ultimately deciding what makes a good photograph.

During this edit, Fiskin also reviewed her contact sheets to determine if she had overlooked any negatives that she might now wish to include in her photographic oeuvre. When she found additional images, she worked with photographer Lane Barden to create prints that for the most part were made from the original negatives. Only in the case of the New Orleans series (plates 212–216) did Barden use a more complex process: he scanned each negative and then availed himself of digital technology to eliminate or enhance areas for improved legibility to create a new negative from which to print the image in the darkroom.

Embedded in the photographs that survived Fiskin's rigorous edit are a number of complications that initially seem to challenge the characteristics she so carefully put into play. The small size of each image, when viewed on the wall or reproduced at actual size in a book, invites close scrutiny while simultaneously seeming to deny entry. Even though Fiskin equates the act of looking at her images with the act of looking through the camera's viewfinder, the distance between the viewer and the subject is not shortened, as curator Ann Goldstein has contended.[30] Instead we seem to be impossibly far from the subject. It also seems to defy logic that entire buildings, landscapes, or the sprawl of a city like Los Angeles can be contained in such a small area. Walter Benjamin summarized this push-pull sensation in his definition of aura as the "unique phenomenon of a distance, however close it may be" in his 1936 essay "The Work of Art in the Age of Mechanical Reproduction."[31] The ability to read details at this minuscule scale is further thwarted by Fiskin's preference for an exaggerated tonal range and blasted-out passages created by light-drenched surfaces in the series prior to 1984. Her propensity to backlight the architectural subjects in many of these images further frustrates our ability to glean information. We are

forced to intuit details, textures, and the play of light and shade based on a priori experiences of similar places and things. Her choice of high-contrast paper and her practice of developing for the blackest blacks and whitest whites would have resulted in the image bleeding into the wide margins of the larger sheet of photographic paper on which she printed were it not for her decision to include the edges of the negative to isolate and contain the image. Despite the framing device provided by the negative's edges, the continuous surface created by placing the image as well as the surrounding margins on the same field of paper rebuffs our desire to read the rectangle or the square as a window leading the eye to an illusionistic space.[32]

The combined effect of these strategies is a sense of reduction, which contributes a fundamental quality of abstraction to Fiskin's images. This is at its most extreme in several photographs in the Military Architecture and Desert series, most notably plate 71. Fiskin has spoken about the influence of minimal sculpture on her work, and even about thinking of each of her photographs as a sculpture.[33] Each photograph represents a miniaturized, self-contained world she created by choosing what to photograph and how to frame it, both in the camera's viewfinder and on the sheet of photographic paper. The image is not intended to document either the object or the place it presents.

Fiskin's choices extend to the space of the gallery, where she exhibits her photographs in a single row that reveals the full range of variations within each series. Particularly for the architectural series, this presentation suggests an interest in typology, a strategy used by many minimalist and conceptual artists to study variations within a type and subsequently adopted by numerous photographers, such as Bernd and Hilla Becher, to introduce analysis and order to groups of similar images. Fiskin's work has been included in several exhibitions that deal with typologies, but unlike the Bechers she never adopted the grid form of presentation, which encourages comparisons based on horizontal, vertical, and diagonal adjacencies. In his essay for the catalogue of the 1991 exhibition *Typologies: Nine Contemporary Photographers*, which included both Fiskin's and the Bechers' work, curator Marc Freidus describes the goal of typologies as follows: "The redundancy of images may seem visually monotonous at first, but ultimately each example speaks to us. Once we begin to discern which characteristics are shared and which are specific, we can reap the understanding that is the goal of typology."[34] Within the Bechers' extensive archive of water towers, blast

furnaces, lime kilns, cooling towers, winding towers, gas tanks, and silos throughout western Europe, or framework houses in the Siegen district of North Rhine–Westphalia, individual photographs reveal countless variations within a type, with the typological presentation in grids of photographs or monographic publications ultimately distilling the essence of that type (fig. 6). Although Fiskin's architectural series similarly display related structures, they are generally less formulaic in their approach. In particular, the proportion of the structure within the frame and also the positioning of the structure either parallel or at an angle to the picture plane lends an individualizing quality that conveys as much about the unique aspects of the structure as about her response to it. This can be most keenly observed in the Military Architecture series (plates 36–51). Finally, attempts to create neat categories within a series often unravel in Fiskin's work, as critic Christopher Knight concludes with regard to the Dingbat series: "Dozens of nonsensical stylistic categories were invented for these ubiquitous (and nonetheless weird) buildings, categories such as 'Peaked Roofs,' 'Geometrics,' 'Side Stairways,' and—the giveaway—'Eccentrics.' Ordinary dingbats are, by definition, eccentric. Fiskin's photographs restored the sense of free and unpredictable serendipity that is always lost through the encrustations of time."[35]

Fiskin has taught in the School of Arts at the California Institute of the Arts in Valencia since 1977, serving first on the Photography faculty, then on the Photography and Media faculty. Citing the school's dictum of "teach yourself," she posits the art educator's greatest challenge as striking a balance between the needs to nurture and to critique and believes she is most successful when enabling students to find their own voice. Increasingly, the independent studies courses Fiskin offers and the student projects she supervises revolve around video, reflecting her own professional practice since the late 1990s. With the completion in 1997 of the semiautobiographical *Diary of a Midlife Crisis*, in which a middle-aged photographer learns to overcome her fear of panning the video camera to introduce movement, Fiskin rekindled the creativity that health issues had brought to a standstill. Two commissioned videos followed: *My Getty Center* for the exhibition *Departures: 11 Artists at the Getty* in 2000, and *What We Think About When We Think About Ships* for the exhibition *Seeing* at LACMALab at the Los Angeles County Museum of Art in 2001. Both focused on objects in the museums' respective collections. The video *50 Ways to Set the Table* was first screened

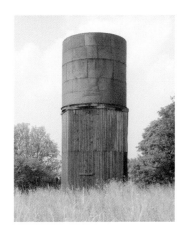 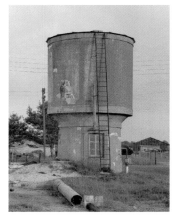 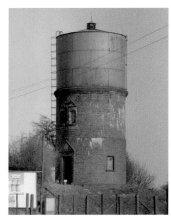

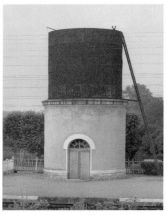 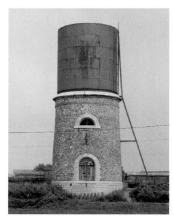

 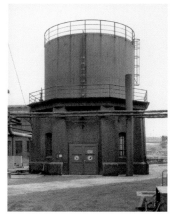

FIGURE 6

Bernd and Hilla Becher (German, partnership 1959–2007), *Water Towers, France and Germany*, 1968–72. Nine gelatin silver prints, each 23.8 × 17.9 cm (9⅜ × 7⁄16 in.). Los Angeles, J. Paul Getty Museum, 84.XM.125.61–69. © Bernd and Hilla Becher

in 2003, *The End of Photography* in 2006, and, most recently, *Guided Tour* in 2010. Each of these works revisits a subject that Fiskin either had or might have photographed in previous years, including a table-setting competition at the Los Angeles County Fair, residential architecture and landscaping in Los Angeles, and art in public spaces that range from museums to arts-and-crafts fairs, corporate plazas, and storefronts. Like her photographs, Fiskin's videos are ultimately concerned with taste and how evolving notions of taste tend to shape our perception of both the commonplace and the noteworthy objects that populate our world. Her videos demonstrate the same wry humor, the same sense of fascination and amusement with the world, that permeates her photographs.

NOTES

This essay grew out of numerous conversations with Judy Fiskin from November 2010 through March 2011 in preparation for this publication. I'd like to express my thanks to Judith Keller, senior curator in the Department of Photographs at the J. Paul Getty Museum, who supported the publication from its inception, and to the staff of Getty Publications, particularly Dinah Berland, senior editor; Anita Keys, production coordinator; Catherine Lorenz, designer; Karen Schmidt, production manager; Deenie Yudell, design manager; and freelance editorial consultants Michelle Nordon, who edited the manuscript, and Karen Stough, who proofread the book, for their talented contributions. My thanks also go to Michael Smith and Tricia Zigmund in Imaging Services for creating the digital files for publication and to all my colleagues in the Department of Photographs for their support in more ways than can be succinctly described here. I am most grateful to Judy Fiskin, for her generosity and willingness to share so many details about her life as a photographer, educator, and artist.

1 Judy Fiskin in "Judy Fiskin Interviewed by John Divola," in *Judy Fiskin*, edited by William Bartman (Beverly Hills, 1988), 25, reprinted herein, pp. 15–21.

2 Fiskin, *Judy Fiskin* (note 1), 7.

3 Robert L. Pincus has argued that Fiskin rescues her subjects "from the ashheap of the unaesthethic"; Susan Kandel suggests that Fiskin "is attracted to aesthetic 'mistakes'"; and Buzz Spector refers to her interest in "the more bizarre reaches of bad taste." See Pincus, "Judy Fiskin: Some Questions of Aesthetics," *Visions Art Quarterly* 4, no. 1 (Winter 1989), 11; Kandel, "The Tiny Photographs of Judy Fiskin," *Art Issues,* no. 16 (February/March 1991), 18; Spector, "Judy Fiskin, Asher-Faure Gallery," *Artforum* 29, no. 8 (April 1991), 132.

4 Fiskin has remarked that had she realized she could have raised the surface on which the photographic paper was placed, her images might have been even smaller. See Fiskin, *Judy Fiskin* (note 1), 4. Richard Armstrong has suggested that the white border around each image exists "as a mat of sorts, functioning spatially more than decoratively." See Armstrong, "Judy Fiskin's Photographs," *Journal: Southern California Art Magazine*, no. 24 (September–October 1979), 27.

5 Fiskin, *Judy Fiskin* (note 1), 26.

6 Fiskin, *Judy Fiskin* (note 1), 3.

7 *Typologies: Nine Contemporary Photographers*, organized by Marc Freidus for the Newport Harbor Art Museum, Newport Beach, California, 1991. *Special Collections: The Photographic Order from Pop to Now*, organized by Charles Stainback for the International Center of Photography, New York, 1992. *Fifty California Small Images*, organized by California State University, Los Angeles, 1972. *Miniature*, organized by California State University, Los Angeles, 1977. *At the Threshold of the Visible: Minuscule and Small-Scale Art, 1964–1996*, organized by Ralph Rugoff for Independent Curators Incorporated, New York, 1997. *Made in California: Art, Image, and Identity, 1900–2000*, organized by the Los Angeles County Museum of Art, 2000. *Los Angeles—Paris—1955–1985*, organized by the Centre Pompidou, Paris, 2006. *This Side of Paradise: Body and Landscape in Los Angeles Photographs*, organized by the Huntington Library, Art Collections, and Botanical Gardens, San Marino, California, 2008.

8 Fiskin, *Judy Fiskin* (note 1), 3–4.

9 Keith Mallory and Arvid Ottar, *The Architecture of War* (New York, 1973). Fiskin included a copy of the book in her presentation of the Military Architecture series in the exhibition *Impetus: The Creative Process*, organized by the Municipal Art Gallery, Los Angeles, 1975, and writes about the book in the exhibition catalogue (see *Impetus: The Creative Process* [Los Angeles, 1975]). See also Henry J. Seldis's review of the exhibition, "The Creative Process in Words and Pictures," *Los Angeles Times*, November 16, 1975, W70.

10 Joan Didion, *Play It as It Lays: A Novel* (New York, 1970); "Los Angeles Notebook," in *Slouching towards Bethlehem* (New York, 1968), 198–205.

11 Fiskin, *Judy Fiskin* (note 1), 19.

12 Raymond Chandler, "Red Wind," originally published in *Dime Detective* (January 1938), reprinted in *Raymond Chandler: Collected Stories* (New York, 2002).

13 Reyner Banham, *Los Angeles: The Architecture of Four Ecologies* (New York, 1971). Also of importance in promoting interest in vernacular architecture was Robert Venturi, Denise Scott Brown, and Steven Izenour's *Learning from Las Vegas* (Cambridge, Mass., 1972).

14 Banham, *Los Angeles* (note 13), 175–77.

15 Ed Ruscha, *Twentysix Gasoline Stations* (Los Angeles, 1962), *Some Los Angeles Apartments* (Los Angeles, 1965), *Every Building on the Sunset Strip* (Los Angeles, 1966), *Thirtyfour Parking Lots in Los Angeles* (Los Angeles, 1967), and *Real Estate Opportunities* (Los Angeles, 1970).

16 William Jenkins, *New Topographics: Photographs of a Man-Altered Landscape* (Rochester, N.Y., 1975), 5.

17 *New Topographics: Photographs of a Man-Altered Landscape*, organized by William Jenkins for the International Museum of Photography at George Eastman House, Rochester, New York, 1975. The exhibition also featured the work of Robert Adams, Bernd and Hilla Becher, Frank Gohlke, Nicholas Nixon, John Schott, and Stephen Shore.

18 Jenkins, *New Topographics* (note 16), 7.

19 Matthew S. Witkovsky, "Photography's Objecthood," in *Lewis Baltz: The Prototype Works* (Göttingen, 2010), [10].

20 Witkovsky, "Photography's Objecthood" (note 19), [10].

21 Fiskin, *Judy Fiskin* (note 1), 20. Many critics who saw Fiskin's images in exhibition noticed these emotional undertones. Alberto Lau commented on the "feeling of solitude and desolation" with which Fiskin's photographs were infused; Demetra Bowles perceived a "desolate and bleak emotional tone" in their overexposed quality; and Louis W. Fox noted the focus in these images on "isolation and loneliness." See Lau, "Landscapes Near and Far," *Artweek* 12, no. 1 (January 10, 1981), 12; Bowles, "Landscapes and Mindscapes," *Artweek* 12, no. 9 (March 7, 1981), 12; Fox, "Formalizing the City," *Artweek* 12, no. 35 (October 24, 1981), 4.

22 John Brumfield, "On Meaning and Significance," *Journal: A Contemporary Art Magazine* 35, no. 4 (Winter 1983), 46. Another critic, Gordon Hazlitt, has referred to Fiskin's photographs as "tiny silent abstractions, composed rather than found"; see Hazlitt, "Verbal Intentions, Visual Results," *Art News* 75, no. 1 (January 1976), 67.

23 Jenkins, *New Topographics* (note 16), 7; Leslie Katz, "An Interview with Walker Evans," originally printed in *Art in America* (March/April 1971), reprinted in *Photography in Print: Writings from 1816 to the Present*, edited by Vicki Goldberg (New York, 1981), 358–69. See especially Evans's comments on page 364: "Documentary? That's a very sophisticated and misleading word. . . . The term should be *documentary style*. An example of a literal document would be a police photograph of a murder scene. You see, a document has use, whereas art is really useless. Therefore art is never a document, though it certainly can adopt that style."

24 Green wrote that unlike nineteenth-century landscape photographers, "who had stood with the civilized world behind them and looked out toward the wilderness . . . the new breed of photographers . . . stood in the open land and pointed their cameras back toward the approaching civilization." See Green, *American Photography: A Critical History 1945 to the Present* (New York, 1984), 163–64.

25 Pincus has observed that "Fiskin's leitmotif is the nature of taste"; Marc Selwyn notes that "Fiskin questions the forces, both sociopolitical and internal, that shape our aesthetic decisions." See Pincus, "Judy Fiskin: Some Questions of Aesthetics" (note 3), 12; Selwyn, "Judy Fiskin, Newspace, Los Angeles," *Flash Art*, no. 145 (March/April 1989), 117.

26 Fiskin, *Judy Fiskin* (note 1), 20.

27 Terry R. Myers, "Judy Fiskin," *Arts Magazine* 65, no. 8 (April 1991), 82. Fiskin initially assigned numbers (#318, etc.) to the images in her Some Art and More Art series and later provided descriptive titles for them in the artist's book *Some More Art* (Los Angeles, 1992). All of her photographs are now simply untitled.

28 *Thirty-One Views of San Bernardino*, edited by David Alexander and Richard Preston, poetry by Dick Barnes, photography by Judy Fiskin (Claremont, Calif., 1975).

29 Of the eighteen photographs reproduced in the artist's book *Thirty-One Views of San Bernardino* (note 28), only nine remain.

30 Ann Goldstein, "Judy Fiskin," in *This Is Not to Be Looked At: Highlights from the Permanent Collection of the Museum of Contemporary Art, Los Angeles* (Los Angeles, 2008), 98.

31 Walter Benjamin, "The Work of Art in the Age of Mechanical Reproduction," reprinted in *Photography in Print: Writings from 1816 to the Present*, note 23, translated by Harry Zohn, 325. James Richard Hugunin makes a similar point in an essay he wrote about Fiskin's photographs. He begins his discussion by updating Viennese phenomenologist Karl Kraus's observation that "the closer the look one takes at a work, the greater the distance from which it looks back" to "the closer one looks at a *photograph*, the greater the distance from which it looks back," before continuing with a discussion of aura with regard to Fiskin's work. See Hugunin, "Hey Judy! Let's Went," in *Frequently Rejected Essays* (Los Angeles, 1984), 29.

32 Armstrong, "Judy Fiskin's Photographs" (note 4), 27.

33 Fiskin, *Judy Fiskin* (note 1), 24.

34 Marc Freidus, *Typologies: Nine Contemporary Photographers* (Newport Beach, Calif., 1991), 10. The exhibitions *Typologies: Nine Contemporary Photographers* and *Special Collections: The Photographic Order from Pop to Now* (note 7) also included the work of Ed Ruscha.

35 Christopher Knight, "Judy Fiskin," in *Last Chance for Eden: Selected Art Criticism by Christopher Knight, 1979–1994*, edited by Malin Wilson (Los Angeles, 1995), 58.

INTERVIEW WITH JUDY FISKIN

JOHN DIVOLA

NOTE: *This interview was first published as "Judy Fiskin Interviewed by John Divola" in* Judy Fiskin, *edited by William Bartman (Beverly Hills, 1988). It is reprinted by courtesy of the author and A.R.T. Press.*

John Divola: Your background was in art history. How did you decide to become a photographer?

Judy Fiskin: After the first week of graduate school at Berkeley, I realized they had changed the game on me, and I quit school. I went over to the university employment center and found out that the only thing I qualified for with my BA in art history was clerk typist. So I reenrolled and decided to stay in graduate school until I figured out something else to do. After a year, I came down to L.A. to finish at UCLA. I was taking seminars on modern art with a really wild guy; his name was Kurt von Meier. This was the late sixties, and he was having us do "happenings." We would all get together and go to the airport and watch the planes come in, or he bought a small TV, and we all threw it off the pier. For one seminar, he told us to get hold of a camera and document some image of popular culture. I was given the heart. This was after seven years of art history, looking at lots and lots of images. I don't remember using a camera before this. I looked through the lens and right away I thought, "This is what I want to do."

I learned the basic mechanics from my then brother-in-law, who had a darkroom in his garage and was teaching himself. It was enough to get me going and it accounts for my rather peculiar take on technical things, because he taught me wrong. I mean he didn't know that much. Then I just taught myself after that.

JD: What do you mean when you said they changed the game?

JF: In college you're just having a great time discovering all this stuff. I was in it for the appreciation and not for the information. In graduate school, you were supposed to be thinking about dates—dating every work, putting everything in the proper slot. And even though now in art history there's more of an idea of work in its broad historical context, I wouldn't be interested in that either. When I had to get serious about it in an academic way, I didn't want to.

JD: Did studying art history influence your work as a photographer?

JF: What I think directly translated into my work was the idea of looking at art in tiny reproductions. A lot of my experience of looking at art was in reproductions that weren't that much larger than the size that I make my work now. In Los Angeles at that time, there weren't too many examples of real art to look at.

Also, after spending hundreds of hours in darkrooms looking at thousands of slides, I had quite an image bank stored up in my subconscious.

JD: For the last eight to ten years, I've never seen a photograph of yours any larger than a couple of inches square. Has that been the case from the first, or is that something that you evolved into slowly?

JF: It took me about a year to get down to that size. I did take one class in photography, a summer school class at UCLA. Everybody was doing 8 x 10s. By the end of the class everybody was trying to make 11 × 14s or 16 × 20s, and I had already started trying to make them smaller. They just looked too gross to me. I worked in 5 x 7 for a while, then I got it down to 4 x 5, and within one or two years I got down to the size that it is now: 2¾ inches

square. The way I arrived at it was that it was the farthest that my enlarger would go down. I didn't realize that if I had put a book on the enlarger table I could have made them even smaller, and I'm grateful now that I didn't because I don't know how small I would have made them.

JD: How do you think the small size affects the reading of the image?

JF: For me, looking at small images somehow re-creates the experience of looking through a viewfinder. When you are looking through a viewfinder of a 35 mm camera, the scale disappears; you don't know the size of the object you are looking at. It's like receiving an image directly into your brain. And when you have to get up to the photograph and peer into it, you lose the sense of separation between yourself as a body and that picture as a separate entity.

 At this size they're edible. You don't just scan them. You take them in all at once. The small scale organizes the image visually in a really graphic way. It gives it an immediate impact. Then if you want to look for detail, you can.

JD: You employ other strategies that further undermine an attempt to read detail: your exaggerated tonal scale, the highlights being blasted out. Is that a conscious device for reducing that kind of information?

JF: I never started out with the idea that I wanted to reduce the information in the image. I wanted the photographs to act on me in a certain way and to look a certain way. At the time that I got interested in photography, I also discovered Atget. The first two years I tried to make photographs that looked as much like Atget photographs as I could because I thought his prints were so beautiful. But he was using albumen paper and a big view camera, and I was using silver paper and 35 mm. Reducing the print size and printing high contrast was my version of reproducing the look of albumen paper, which has bleached-out whites and very strong blacks. On silver paper you couldn't make such an extreme print large, so detail had to go.

 But suppressing detail also did something I was very interested in. I was trying to match my mental image of the world, rather than the world itself, and mental images of objects aren't full of detail. If you think "house," you're going to get something very general, and if you want detail, you're going to have to make

an effort to add it. Dropping detail made the photographs more general, like mental images.

JD: Does that particular kind of print have anything to do with creating atmosphere?

JF: When I first started I was really interested in atmosphere. I've developed away from that, but that's true of the first stucco bungalows that I did and then the stuff I did in San Bernardino—and even the military bases to some extent. I was interested in a sort of Raymond Chandler atmosphere—too much sunlight, making you squint, everything really menacing. That's how I picked San Bernardino. I grew up in Southern California, and on my childhood map, after San Bernardino there was a big void that you would fall into if you went any farther. And then one day I was driving through there, and the smog was so thick it was palpable. It made the place look filthy and disgusting, and that was very appealing to me. In my mind, it was a very creepy place. That's why I wanted to photograph there.

JD: To photograph is often compared to an act of redemption—to select from an infinite number of choices that which is to be remembered. In some of your early work there was a sense of redeeming from popular culture certain gestures that otherwise might be dismissed. However, in your work dealing with furniture in museums, the objects that you photograph already populate a catalogue of redemption. Their context, the museum, is an assertion of their significance.

JF: There's a way that you can't avoid that act of redemption as a photographer, especially if you're doing anything that looks at all documentary; the work is going to be read that way anyway. I didn't try to avoid that reading or undermine that reading, but I was more interested in something else: a feeling of the arbitrariness of the world. A metaphor that I've always used for that is aesthetic choice. One of the reasons that I have always dealt so much with kitsch material is that arbitrariness of choice in popular architecture and popular art is quite obvious because the choices are, from our point of view, so often wrong.

 That's why I photographed flower shows. Flower arranging has such a frozen aesthetic. The judges at those shows would take me around and say, "See, that rose is half an inch off." I would nod my head. I couldn't see anything wrong, but this was

an aesthetic that had very, very strict rules. It was an aesthetic, but it was completely awkward. What appealed to me was the idea of so much meticulous care being put into something that turned out so wrong.

Furniture in museums has already been designated and canonized as high art, but a lot of it fits into the same category as flower arrangements. I didn't go photograph Shaker objects in museums. I photographed wild Victorian furniture. I photographed Rococo French furniture from the eighteenth century. Because it's canonized in the museum, people look at it and tick off all these examples of "good taste." But in fact a lot of them are quite bizarre, which puts them in the right territory for me. It gets back to the idea of the photograph as redemption when you say, "Let's look closely at these things and see what's really there." The furniture is being redeemed from conventional notions of beauty. In the photographs the objects are freed to take on a different kind of beauty.

JD: When you photograph a piece of furniture from the eighteenth century, the context it operates within is the present. To some degree it undermines the notion of history.

JF: By making objects appear slightly off, the way that I do in the photographs, by making them appear different from the way they're presented, you have to deal with them as objects of the present. Once you do that, you have to ask, what are they now? We're used to understanding them as direct links to the past—if you have contact with this, you have contact with Louis XIV. In fact, it's not true, and once you throw that notion out, then it becomes very unclear what they are or what your attitude toward them should be. That is always the feeling that I'm trying to get at in whatever I do.

JD: Yet all of your work seems to be anchored in a representation of particular historical eras.

JF: The eras that I've dealt with up until this furniture series have been close to the present, starting from the bungalows of the twenties and thirties, and that does bring up the question of nostalgia. I want to deal with that a little bit. For instance, the desert landscapes—it wasn't just that I wanted to go out and photograph the desert. I was going out and photographing an idea of the desert. That idea of the desert was set in the forties, and I'm sure it

came from forties movies. But I was also working from my own memories of having a lot of childhood vacations in Las Vegas and Palm Springs. But I still don't think of the way that I dealt with it as nostalgic. A friend recently looked at the furniture work and said he thought I was casting a cold eye on my own nostalgia. I think it's nostalgia with a distance, a step back from nostalgia and an acknowledgment that what you're longing for is just another image.

JD: Your work often addresses aesthetics as subject. In more recent work it was the aesthetics of high culture, the objects that literally populate the museum. Your work is a kind of catalogue of the stylistic codes that characterize an era.

JF: I'm looking at the idea of how those definitions are put in place. One way to define each era is through this kind of visual shorthand that gets constructed. Once you've got some distance in years from that, it looks more and more arbitrary. In Some Aesthetic Decisions, the flower show images, I was dealing with an aesthetic that had been frozen in the fifties. This was already 1984, and here was this whole group of people who were doing something very consciously aesthetic, but the aesthetic was thirty years old and they didn't have any idea that that was so. I found that an interesting thing to be dealing with.

JD: The idea of arbitrariness sounds sort of metaphysically bleak.

JF: It is. What I am dealing with over and over is having your ease in the world pulled out from under you, because I don't feel easy in the world. The flip side of that, the positive side of that, is that it makes a clearing where you can see the world with fresh eyes, see the world with a sense of wonder. Once the comfortable meaning of things slides away, it makes you aware of your own contingency in the world, but it opens objects up for you to really see them and have a strong experience of them. That's a positive thing, and it can be applied to everything—even sixties apartment buildings.

JD: Weren't the emotions you wanted to inject often emotions of detachment?

JF: They were about being detached when you didn't want to be detached.

JD: There's an emphatic reticence about them.

JF: Yes. During my career as a depressed person that was part of my personality. In fact, at that time of my life, I didn't talk much. I hung around with people who would talk for me. But I also think that the reticence in the work is an attempt to allow a thing to speak for itself. If I leave an object seeming like it doesn't have enough meaning, I think it just allows it more room to be there, to have presence.

JD: That notion of presence is interesting because your work has often seemed impenetrable. All that's allowed to come through is this stylistic code or this idea of a type of an object.

JF: Impenetrable, opaque, obdurate: these are good terms to apply to the work. They all express something about what the world feels like to me.

JD: To call all aesthetic decisions arbitrary undermines the whole pretense of the arts as this notion of humanizing the world, or inflecting objects with a sense of individual character and value.

JF: But that is just what makes it arbitrary. For every era of artmaking there is some new agreed-upon code. If you don't agree on it, then it doesn't mean anything. That's one of the things that conceptual artists explored—that is, looking at art as an activity that depends on consensus. If the consensus dies, then the object is up for redefinition. The game changes all the time; for me, if you look at that too closely, you're getting into real queasy territory. How do you say anything means anything if that's the case? I'm not making art in which everything that I'm doing is meant to lead you to that conclusion. Instead, I'm trying to make that into a visual experience that leaves you somewhat uneasy.

I do appreciate these objects that I'm looking at. But I have to make up my own terms of appreciation, redo the objects; then I can appreciate them. In that sense, I am doing a kind of photographic rescue mission, but I know its limits.

JD: I'd like you to talk about the cataloguing approach that exists in your work. You often work with the methodology of the catalogue, exploring variations within a group of similar objects.

JF: I think there's something basically appealing about variations on a theme. A lot of people in photography have done that. I think photography is a great medium for cataloguing because you can gather information endlessly. In the Dingbat series, I did a lot of photographs of apartment building facades that were decorated with geometric motifs. You could drive through Los Angeles and say, "Boy, there's all these apartment buildings and some of them have circles on them, and some of them have triangles and some of them have squares," but you couldn't have the experience of seeing them all together except in a series of photographs.

Also, that kind of serial structure is a benign way of working out greed. It's a kind of stand-in for owning things. It satisfies your acquisitiveness.

JD: Photography often has been described pejoratively as a form of shopping.

JF: Yeah, and I'm a great shopper, too. But if that's all it was, it wouldn't be enough. The catalogue structure does lots of other things. It lets me put things together in a way that feeds into the idea of the arbitrary. That showed most clearly in the Dingbat series. I had so many photographs that I was able to divide them into several different subseries. On the surface it sort of looked like an encyclopedia of sixties architecture, but underneath, if you looked at all the different categories, they didn't make sense as categories. One category was buildings with side stairways, another was geometric motifs, another Japanese rooflines. Those categories don't really add up to anything when you put them together. I had one category of peaked roofs and another category of Japanese rooflines, but Japanese rooflines also have peaked roofs. They could have all gone in the peaked roofs category. It started to fall apart on you if you were paying attention. It was about dissolving order, but I did it in a playful way. I put together three buildings that had decorative screens on their facade with a building that had a tiny diamond-patterned window, because that looked like a screen to me.

JD: You generally emphasize the concrete, discrete objects as opposed to photographs of broad fields of information. It seems very consistent, even in the desert work.

JF: I think that's a question of sensibility. One of the reasons I chose a desert landscape as opposed to a mountain landscape is that the desert is where you can see things discretely. I got images of a cactus or a bush just sitting out there by themselves. I was able to silhouette them, so they really stand out. I also had a verbal

idea, which was "rock," "mountain," "sagebrush." I was going to try to come up with some primal image of those three things together. I got one photograph that I think finally did that. That goes back to the idea of working from idealized images in my mind.

JD: One of the fascinating things about photography, as opposed to many of the other media, is that it pulls you out into the world. It pulls you into what's outside the house. Is that any sort of motivation in relation to the work?

JF: When I come up with something I want to look at, some part of the world opens up. When I was looking at little stucco buildings, since L.A. is so full of those, L.A. became a whole playground for me, because I was not just looking at them and appreciating them, but I could really focus on them. I was looking at them with a purpose. The interesting and unfortunate thing is that when I'm through with the series I could care less about those buildings. The world keeps opening up and closing down through this process.

Making something that you really like is like getting a shot of morphine. It's pleasure. Unfortunately for artists, you can't keep getting that hit from the same thing over and over again. That's why your work has to keep changing to some extent. You get bored within the work. That's what keeps me going, to have that pleasure and not be bored.

JD: All of your work is shot either in the Los Angeles area or the New York area. Why is that?

JF: First of all, shooting in L.A. was a matter of circumstances. It's where I grew up, it's where I mostly went to school, it's where I discovered architecture, and it's full of different kinds of interesting architecture. There was fertile ground for me here. Also, when I started, I was interested in the atmosphere of this semi-arid place with lots of light. I think again I wanted to re-create something about my memories of childhood that way. Also, for many years I felt like I couldn't live anywhere else, couldn't have an identity anywhere else. That's no longer true.

I went to shoot in New York because of what I would see when I took trips there, driving in from the airport, going through Queens. At one point in Jamaica the expressway is elevated, and you see all these little houses with all kinds of different siding—weird, at least to West Coast eyes. I was fascinated by that. At a certain point I realized I could go there and photograph

those houses. There was a whole different kind of vernacular architecture there.

I would like to shoot in all different kinds of places. I'm interested in domestic architecture in Germany, pictures I've seen of vernacular architecture in Africa, especially Mali. This stuff is on my mind. In fact, I don't enjoy travel that much, but I have this terrible feeling that I might actually get myself to some of these places to do this. On the one hand, I would really like to do the work. On the other hand, I think I would hate the trip. So, we'll see. In the meantime, I'm about to go to New York for six months to shoot Stick Style Victorian architecture on the Jersey Shore.

JD: Is there any difference in working in New York or Los Angeles?

JF: Yes. People reacted differently to what I was doing in each place. People get upset when they see you outside photographing their houses. I learned to tell the story that seemed to satisfy the most people the most quickly. When I first started in L.A., I used to tell the truth. I would say, "I'm a photographer" or "I'm an artist and I'm doing this series on small houses." Nobody believed that. I learned to say something else when I was in L.A.: "I'm a location scout and there's going to be a movie made and your house might be in it." There's nobody in L.A. who didn't go for that. Really, it's just a question of what people are used to and know about.

Then I went to New York, and I was photographing in Brooklyn. The first person that came out to question me, I said, "Well, I'm an artist." Total relaxation. They got that right away. They said, "Oh, you're an artist. We have some artists moving in around the corner. If you think this house is interesting, there's an even more interesting house around the block." This happened over and over again. In New York the concept of being an artist has reached everyone. No matter what people say about L.A. as an art center, it does not get you anywhere to tell people in L.A. that you're an artist.

JD: What was it like to shoot in the desert?

JF: I always went out there alone. Before I went I was really interested in reading survival books. I was pretending to myself that I was going to go out there and get lost. So I learned all this stuff like how to burn the tires on your car to signal for help. I sent away for a huge orange plastic tarp that spelled out HELP, to throw over the top of your car if you got lost. I put together a whole survival

kit. I had a little snakebite kit. I carried boards in case the car got stuck in the sand, even though when I did get stuck in the sand I had no idea how to use them. I had to go find someone who was parked in a trailer nearby to get my car out of the sand. The truth is when I went out there I never went more than a five-minute walk away from the highway.

Actually, I've had lots of fantasies about being in danger when I'm shooting, and I've heard other photographers talk about that, too. When you're walking around behind a camera, you lose track of what's going on around you, and I think that makes you feel vulnerable. There was the danger of hostile people coming out of their houses at me. How was I going to handle them?

JD: What was it like photographing military architecture?

JF: I thought it was going to be incredibly difficult to get permission to photograph. In every case except for one, all I had to do was to call up the public information office at that base and say that I was interested and sound like my interest was positive, and they rolled out the red carpet for me. Someone there would take me all over the base. Nobody ever questioned what I was doing. Nobody ever checked my references, nobody ever called me to see if I was at the right telephone number. At some bases they let me go around by myself.

The best place for my purposes was a Seabee base in Ventura. The Seabees are the construction battalion, and in peacetime they go all over the world to help rebuild in places that have had natural disasters. There were these big fields of what my guide called "materiel," which changed from week to week. There were things like giant rubber water bags that they would drop on places where there had been earthquakes. But most of what was there was unrecognizable, and there were acres of it. For me, it was like finding miles of functional minimal sculpture to photograph.

The other thing they did on this Seabee base was train soldiers in construction. They had a miniature block of houses that they would have the trainees build. Then, when new people came in, they would tear down the houses, trim the wood, and rebuild them. So the houses kept getting smaller and smaller until they used up the lumber. They also had two-foot-high telephone poles so the guys could learn to string telephone wire without worrying about falling off the pole.

JD: Is the perspective of a woman evident within your work in any way?

JF: I think so. It's subtle. It can only be seen in a certain context. When I first started showing my work, some of the ideas I was working with were generally in the air. There were a bunch of photographers who were grouped together at that time after a show called *New Topographics*. New Topography was work that dealt with the landscape and the urban landscape in a very neutral-looking way, coming out of the documentary tradition of Walker Evans. It wasn't totally documentary because a lot of emphasis was given to a certain kind of beautiful print, but an air of absolute neutrality toward the subject matter was essential. All the work of the New Topographers was men's work.

My work came out at the same time, and there were ways in which it was related to theirs. I wanted the work to look objective in a certain way, too. On the other hand, arbitrariness and depression and bleakness are not so present in the work of the men who did New Topography. I wanted to inject certain kinds of emotional states into this neutral-looking work. That, I would say, is more female and less male.

When I photographed the flower arrangements, part of what drew me to that was the milieu. It was such a paradigm of the options traditionally open to women. I got to know some of the women, and when they felt comfortable with me, they would say, "We're not doing flower arranging; we're doing sculpture." But they're not doing sculpture in a creative way, and they're not doing sculpture in a professional way, although the competitions they go through have all the trappings of something highly serious. It's a picture of an activity in which women were doing this thing that was parallel to what men did, except the stakes and the rewards were very low. Women get to pretend to do what men do. These women were all middle-class and upper-middle-class, and very conventional, something I feel that I narrowly escaped in my life.

I remember sitting in an auditorium when one of the clubs was giving a demonstration of flower arranging, and I had the fantasy that the doors were going to swing shut. We were all going to be locked in there forever. I was going to be the only one who wasn't really a part of this world, but I was going to have to live in there, the flower-arranging world, for the rest of my life. I think that's in the work.

JD: Could you talk a bit about the influences that surround your work?

JF: The specific influences started back when I was studying medieval architecture. I liked Romanesque architecture, which is heavy and squat, with sort of powerful generalized spaces. I was drawing on this taste for heavy and somewhat awkward architecture when I decided to look at vernacular architecture.

Then there was Atget. And after Atget, Walker Evans was a strong influence because of the way he centered objects, the way he was interested in looking at objects, in vernacular architecture, and the way he made vernacular architecture look monumental. My earliest work on architecture was trying to make the stuff look monumental. It doesn't anymore, but it did at the beginning. After that there was an influence that I didn't see at the time, even though it was all around: minimal sculpture. But when I look at my photographs of simple buildings centered in the middle of a square frame, I have to think that somehow something about the minimalist aesthetic filtered into me.

Then there are things that look like influences, like the Bechers, that I just don't think were influences at the time this work was developing. As for the work of the New Topographers, I had pretty much gotten to all the essential elements of what I was doing before I became aware of them. I was dismayed to find out that there was this bunch of other people who were doing such similar work.

JD: Often based in the aesthetics of minimal sculpture.

JF: I think it also comes from looking at a lot of nineteenth-century landscape photography and really loving it, but having to deal with the problem of the fact that it had already been photographed. How do you make those photographs again in a contemporary way? I think that was a problem that they were solving and that I was solving too. That was another very heavy influence: nineteenth-century American landscape photography.

JD: How do you know when you're finished with a body of work?

JF: Usually these days, I just make work for a show. When I have the show, that's it for the series. For instance, I think when I had the show of the desert series I didn't feel like I was finished. I still wanted to go out to the desert. I was still interested in it. But once I had the show it was dead. I couldn't do it anymore.

Other times, you see things on the proof sheet that you know would make good photographs for that series, and you just don't want to do them anymore. It just gets boring. You've tapped it out in some way. You just know. I mean it's as simple as that.

JD: The process of art history is to take a category of objects and reduce it into propositions about what it means. It seems to me that you have great skepticism about that reduction.

JF: Yes. It's because I'm more interested in creating an experience than in summarizing experience.

My work a lot of times gets talked about as if it were documentary work. My definition of documentary work is photography in which the information is the most important part of the work. In my work, the information is the least important part. It's there, and the work wouldn't mean the same thing without it, I don't deny it, but it isn't structured around the information. The most interesting part to me is the visual play: how many different kinds of one thing I can put together, how these things look when I make them into prints. The most interesting part is looking at this little universe of representation that I can make out of the world.

• • •

John Divola is an artist and professor of art at the University of California, Riverside.

PLATES

STUCCO 1973–1976

PLATES 1–21

PLATE 1

PLATE 2

PLATE 3

PLATE 4

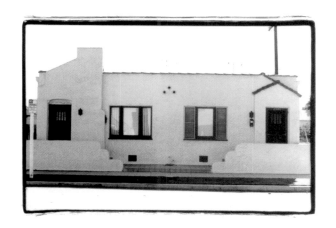

PLATE 5

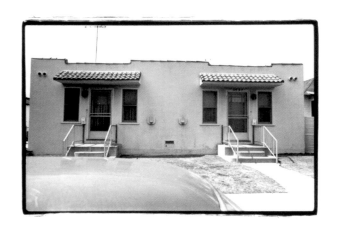

PLATE 6

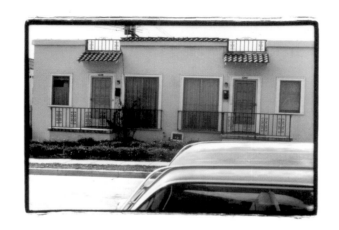

PLATE 7

PLATE 8

PLATE 9

PLATE 10

PLATE 11

PLATE 12

PLATE 13

PLATE 15

PLATE 16

PLATE 17

PLATE 18

PLATE 19

PLATE 20

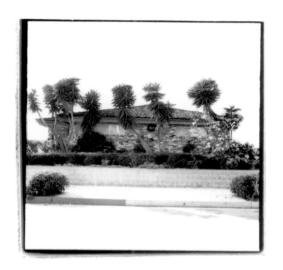

PLATE 21

35 VIEWS OF SAN BERNARDINO 1974

PLATES 22–35

PLATE 22

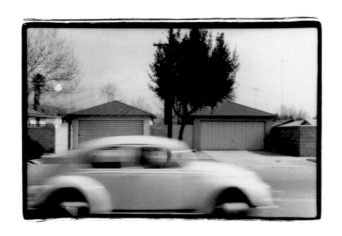

PLATE 23

PLATE 24

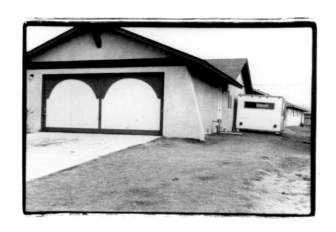

PLATE 25

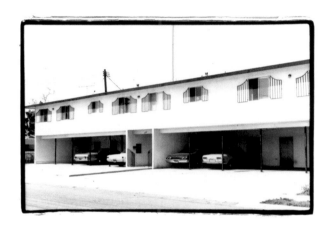

PLATE 26

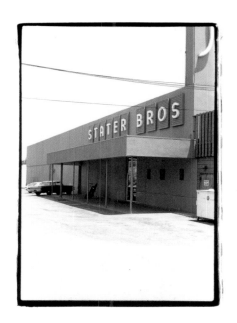

PLATE 27

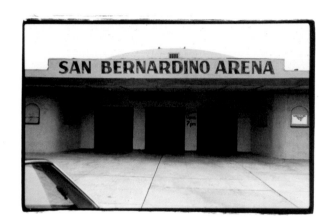

PLATE 28

PLATE 29

PLATE 30

PLATE 31

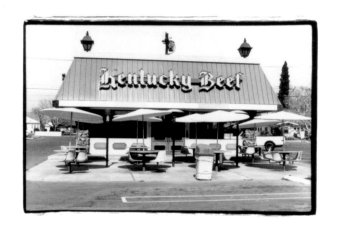

PLATE 32

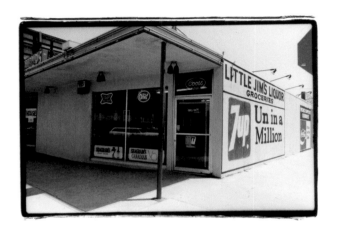

PLATE 33

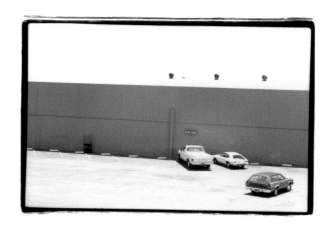

PLATE 34

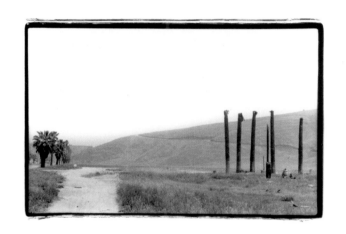

PLATE 35

MILITARY ARCHITECTURE 1975

PLATES 36–51

PLATE 36

PLATE 37

PLATE 38

PLATE 39

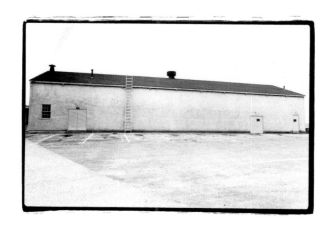

PLATE 40

PLATE 41

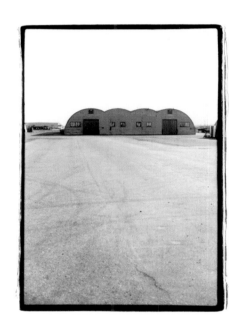

PLATE 42

PLATE 43

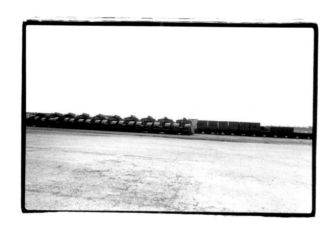

PLATE 44

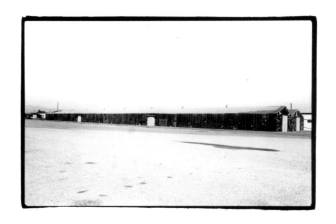

PLATE 45

PLATE 46

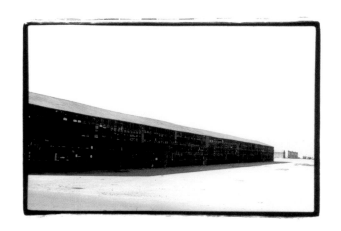

PLATE 47

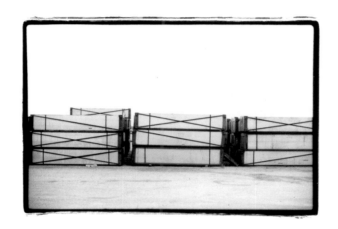

PLATE 48

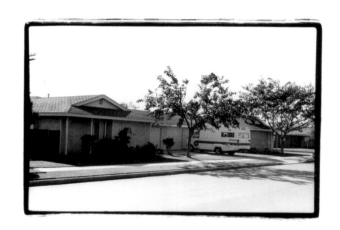

PLATE 49

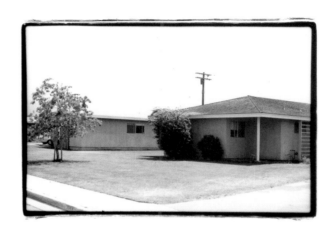

PLATE 50

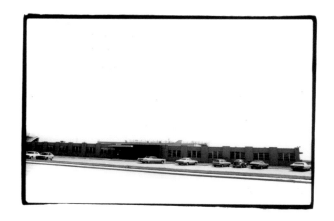

PLATE 51

DESERT 1976

PLATES 52–78

PLATE 52

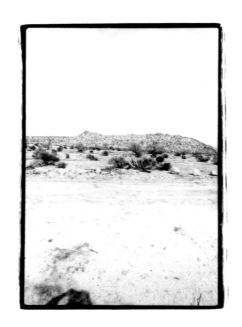

PLATE 53

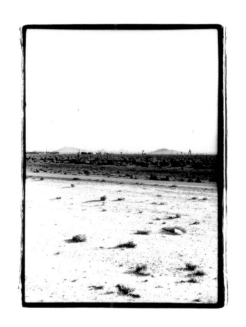

PLATE 54

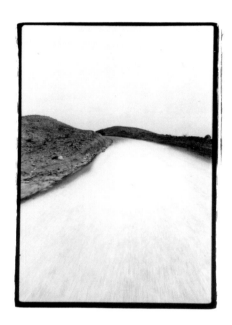

PLATE 55

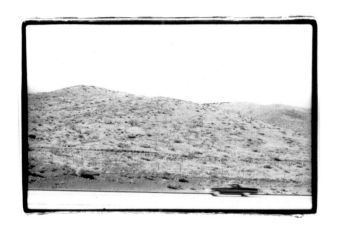

PLATE 56

PLATE 57

PLATE 58

PLATE 59

PLATE 60

PLATE 61

PLATE 62

PLATE 63

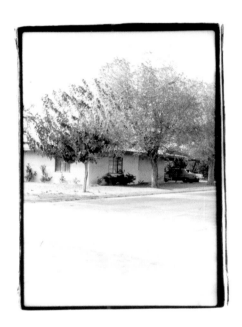

PLATE 64

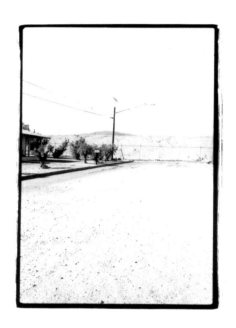

PLATE 65

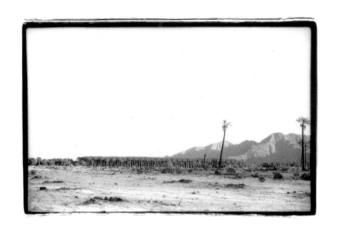

PLATE 66

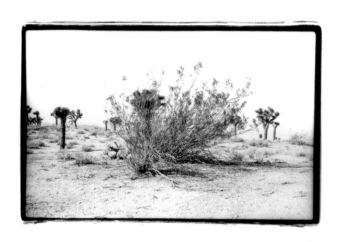

PLATE 67

PLATE 68

PLATE 69

PLATE 70

PLATE 71

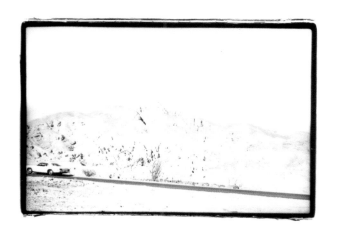

PLATE 72

PLATE 73

PLATE 74

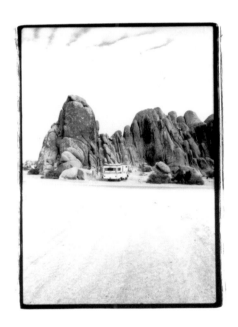

PLATE 75

PLATE 76

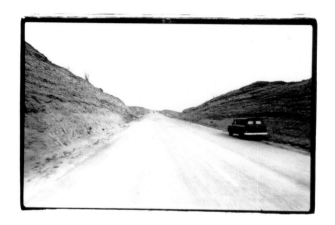

PLATE 77

PLATE 78

LONG BEACH 1980

PLATES 79–95

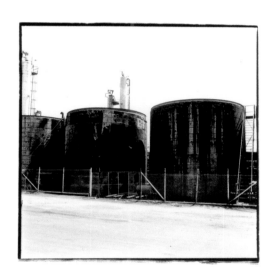

PLATE 79

PLATE 80

PLATE 81

PLATE 82

PLATE 83

PLATE 84

PLATE 85

PLATE 86

PLATE 87

PLATE 88

PLATE 89

PLATE 90

PLATE 91

PLATE 92

PLATE 93

PLATE 94

PLATE 95

DINGBAT 1982–1983

PLATES 96–137

PLATE 96

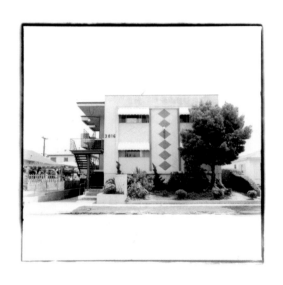

PLATE 97

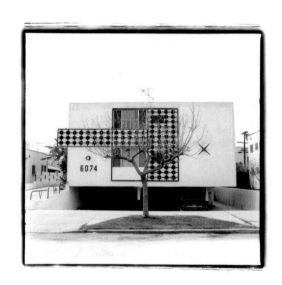

PLATE 98

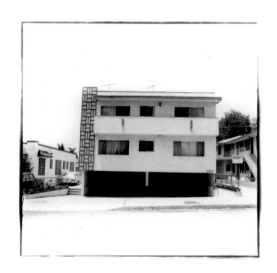

PLATE 99

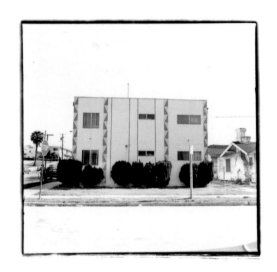

PLATE 100

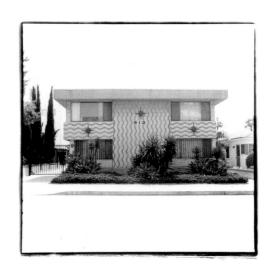

PLATE 101

PLATE 102

PLATE 103

PLATE 104

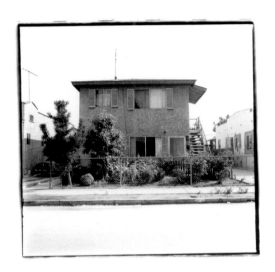

PLATE 105

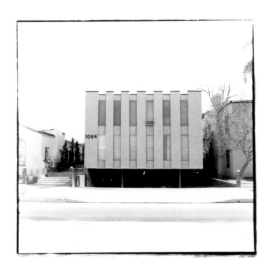

PLATE 106

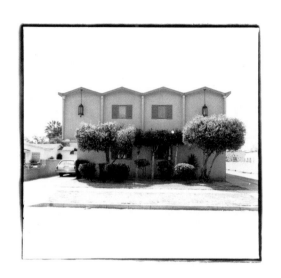

PLATE 107

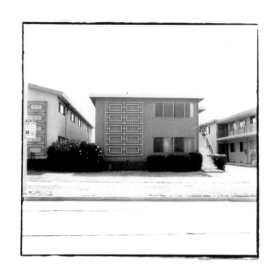

PLATE 108

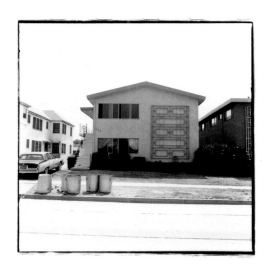

PLATE 109

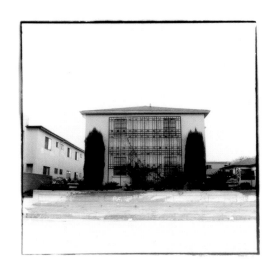

PLATE 110

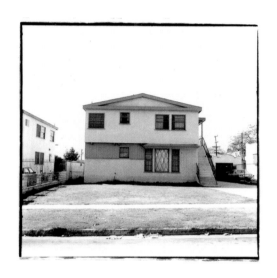

PLATE 111

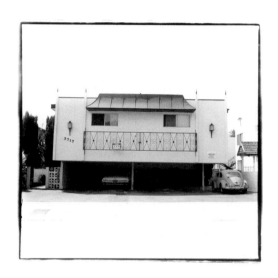

PLATE 112

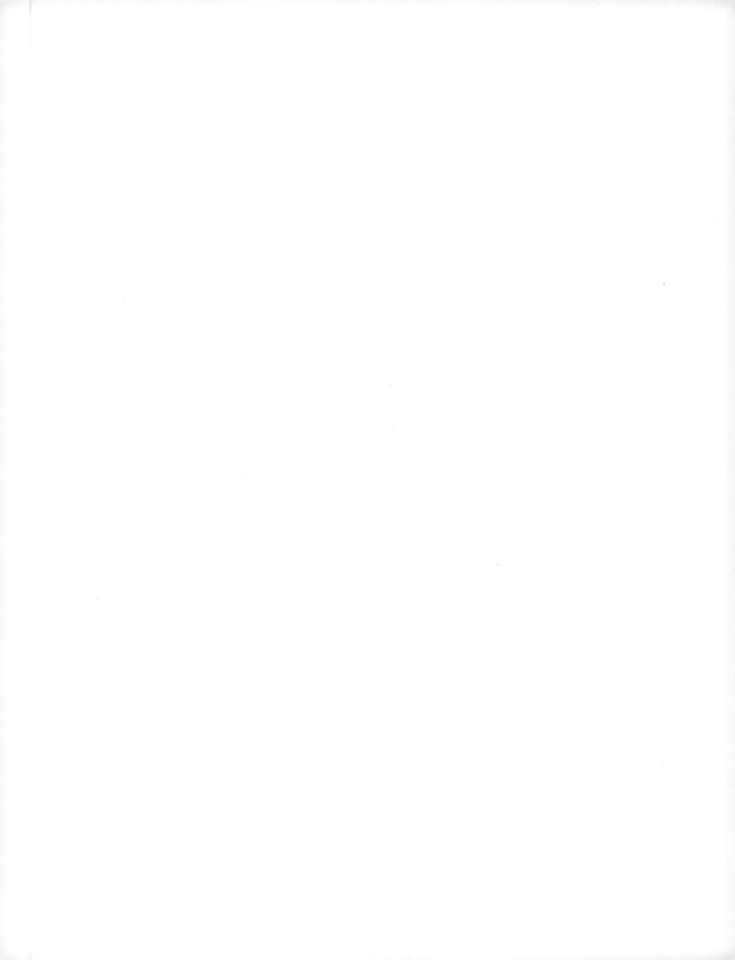

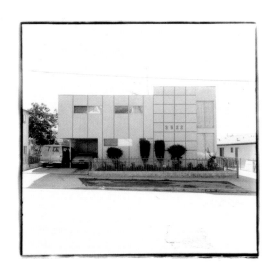

PLATE 113

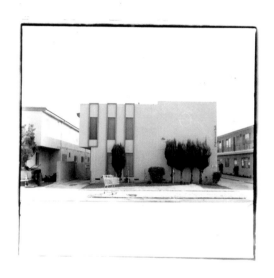

PLATE 114

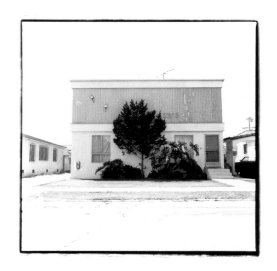

PLATE 115

PLATE 116

PLATE 117

PLATE 118

PLATE 119

PLATE 120

PLATE 121

PLATE 122

PLATE 123

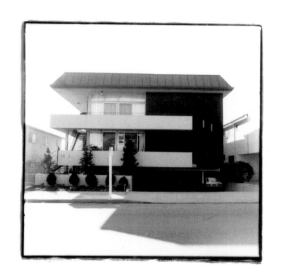

PLATE 124

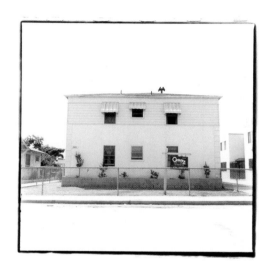

PLATE 125

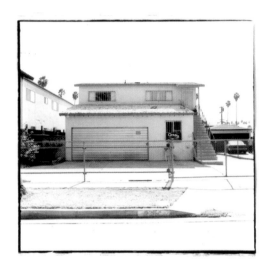

PLATE 126

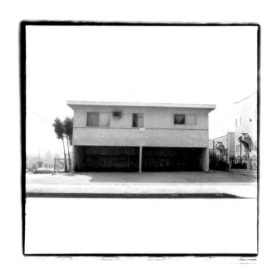

PLATE 127

PLATE 128

PLATE 129

PLATE 130

PLATE 131

PLATE 132

PLATE 133

PLATE 134

PLATE 135

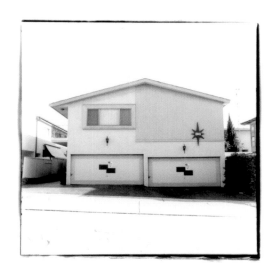

PLATE 136

PLATE 137

SOME AESTHETIC DECISIONS 1983–1984

PLATES 138–165

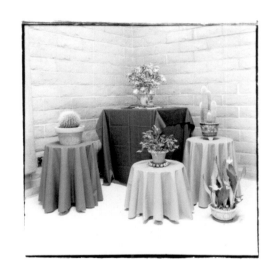

PLATE 138

PLATE 139

PLATE 140

PLATE 141

PLATE 142

PLATE 143

PLATE 144

PLATE 145

PLATE 146

PLATE 147

PLATE 148

PLATE 149

PLATE 150

PLATE 151

PLATE 152

PLATE 153

PLATE 154

PLATE 155

PLATE 156

PLATE 157

PLATE 158

PLATE 159

PLATE 160

PLATE 161

PLATE 162

PLATE 163

PLATE 164

PLATE 165

MY TRIP TO NEW YORK 1984–1986

PLATES 166–211

PLATE 166

PLATE 167

PLATE 168

PLATE 169

PLATE 170

PLATE 171

PLATE 172

PLATE 173

PLATE 174

PLATE 175

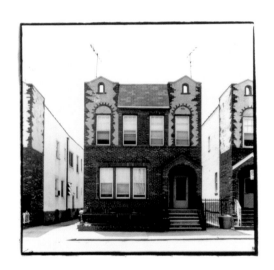

PLATE 176

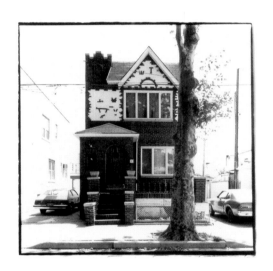

PLATE 177

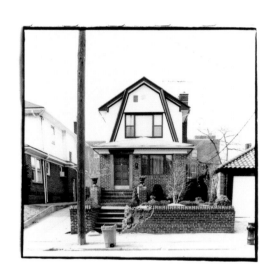

PLATE 178

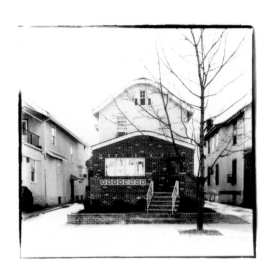

PLATE 179

PLATE 180

PLATE 181

PLATE 182

PLATE 183

PLATE 184

PLATE 185

PLATE 186

PLATE 187

PLATE 188

PLATE 189

PLATE 190

PLATE 191

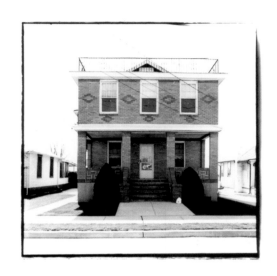

PLATE 192

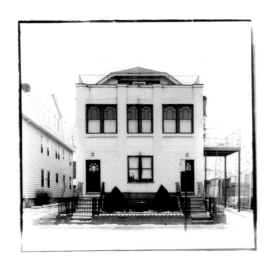

PLATE 193

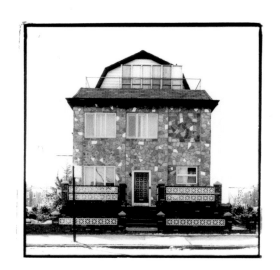

PLATE 194

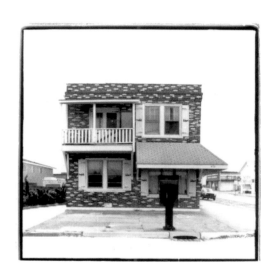

PLATE 195

PLATE 196

PLATE 197

PLATE 198

PLATE 199

PLATE 200

PLATE 201

PLATE 202

PLATE 203

PLATE 204

PLATE 205

PLATE 206

PLATE 207

PLATE 208

PLATE 209

PLATE 210

PLATE 211

NEW ORLEANS 1985

PLATES 212–216

PLATE 212

PLATE 213

PLATE 214

PLATE 215

PLATE 216

JERSEY SHORE 1986–1988

PLATES 217–219

PLATE 217

PLATE 218

PLATE 219

PORTRAITS OF FURNITURE 1988

PLATES 220–232

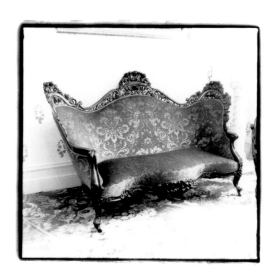

PLATE 220

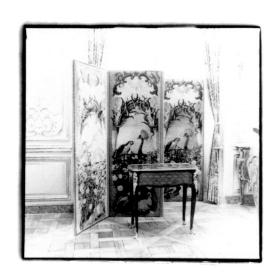

PLATE 221

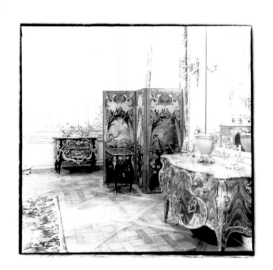

PLATE 222

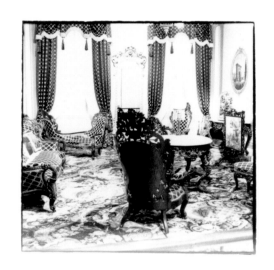

PLATE 223

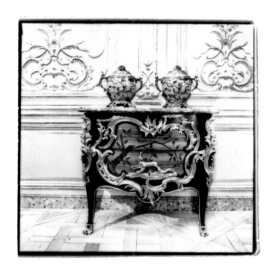

PLATE 224

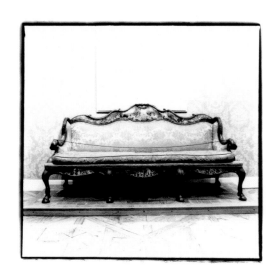

PLATE 225

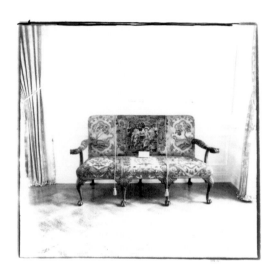

PLATE 226

PLATE 227

PLATE 228

PLATE 229

PLATE 230

PLATE 231

PLATE 232

NEW ARCHITECTURE 1988

PLATES 233–250

PLATE 233

PLATE 234

PLATE 235

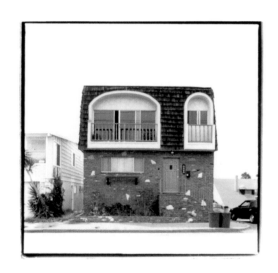

PLATE 236

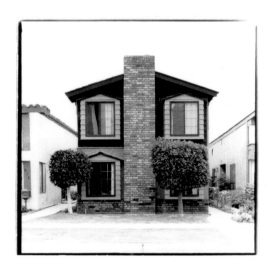

PLATE 237

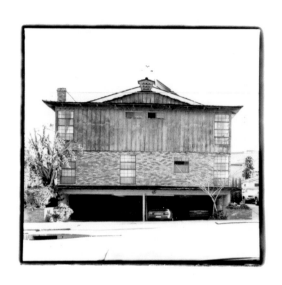

PLATE 238

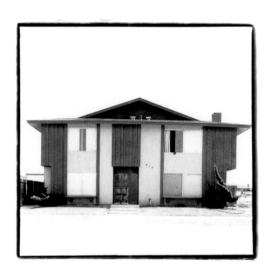

PLATE 239

PLATE 240

PLATE 242

PLATE 243

PLATE 244

PLATE 245

PLATE 246

PLATE 247

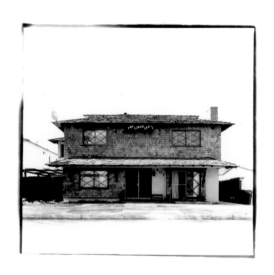

PLATE 248

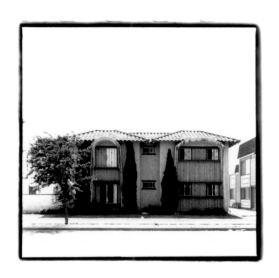

PLATE 249

PLATE 250

SOME ART 1990

PLATES 251–269

PLATE 251

PLATE 252

PLATE 253

PLATE 254

PLATE 255

PLATE 256

PLATE 257

PLATE 258

PLATE 259

PLATE 260

PLATE 261

PLATE 262

PLATE 263

PLATE 264

PLATE 265

PLATE 266

PLATE 267

PLATE 268

PLATE 269

MORE ART 1992–1995

PLATES 270–288

PLATE 270

PLATE 271

PLATE 272

PLATE 273

PLATE 274

PLATE 275

PLATE 276

PLATE 277

PLATE 278

PLATE 279

PLATE 280

PLATE 281

PLATE 282

PLATE 283

PLATE 284

PLATE 285

PLATE 286

PLATE 287

PLATE 288

A NOTE ON THE PLATES

All photographs reproduced in the plate section are untitled, gelatin silver prints on white photographic paper, each ranging in size from 17.6 × 12.8 cm (7 × 5 in.) to 20.3 × 14.6 cm (8 × 5¾ in.), inserted into frames with outer dimensions ranging in size from 23.9 × 19.1 cm (9⅜ × 7½ in.) to 26.6 × 20.6 cm (10½ × 8⅛ in.), and shown here at the approximate, framed size. All photographs were printed at the time that each series was made (see table of contents for dates), with the exception of the following works, which were printed in 2006: PLATES 21, 81, 83, 166, 194, 195, 203, 205, 209, 212–216, 224, 236, 237, 241, 243, 246, 247, 258–261, 263, 270, and 288.

Prints of the following works are included in the collection of the J. Paul Getty Museum, with accession numbers as follows:

PLATE 1: 2008.36.1 PLATE 102: 2008.36.10

PLATE 10: 2008.36.2 PLATE 103: 2008.36.11

PLATE 12: 2008.36.3 PLATE 138: 2008.36.14

PLATE 96: 2008.36.4 PLATE 140: 2008.36.12

PLATE 97: 2008.36.8 PLATE 154: 2008.36.13

PLATE 98: 2008.36.7 PLATE 155: 2008.36.15

PLATE 99: 2008.36.6 PLATE 186: 2008.83

PLATE 100: 2008.36.9 PLATE 224: 2010.45

PLATE 101: 2008.36.5

All Judy Fiskin images are reproduced courtesy of the artist and Angles Gallery, Los Angeles.

CHRONOLOGY

1945
Born April 1, 1945, in Chicago. Family moves to Los Angeles the following year.

1962–66
Undergraduate studies in art history at Pomona College, Claremont, Calif. Spends junior year abroad in Paris and travels throughout France.

1966–67
Graduate studies in art history at the University of California, Berkeley. Marries first husband, Jeffrey Fiskin.

1968–69
Continues graduate studies in art history at the University of California, Los Angeles; receives master's degree. Begins to experiment with photography.

1969–70
Compiles and edits the journals of the architect Richard Neutra.

1970
Enrolls in a photography course taught by Edmund Teske during the summer session at the University of California, Los Angeles.

1971
Enrolls in a photography course at Art Center College of Design in Pasadena, Calif.

1972
Receives Purchase Award from California State University, Los Angeles.

Group exhibition: *Fifty California Small Images*, California State University, Los Angeles (catalogue).

1973
Begins Stucco series, on which she will work for three years.

Becomes codirector of Womanspace Gallery, Los Angeles.

Group exhibitions: *Alumni Exhibition*, Pomona College, Claremont, Calif. *Exposures: Photography and Its Extensions*, Womanspace Gallery, Los Angeles.

1974
Creates 35 Views of San Bernardino series.

Group exhibitions: *Heavy Light*, Pasadena City College, Pasadena, Calif. *Photography 1974*, Art Rental Gallery, Los Angeles County Museum of Art.

1975
Creates Military Architecture series.

Solo exhibitions: *Military Architecture*, University of California, Irvine. *Thirty-One Views of San Bernardino*, California State College, San Bernardino; Pitzer College, Claremont, Calif. (artist's book).

Group exhibitions: *Benefit Show and Auction*, Cameraworks Gallery, Los Angeles. *Impetus: The Creative Process*, Los Angeles Municipal Art Gallery, Barnsdall Park (catalogue).

1976
Creates Desert series.

Divorces first husband.

Solo exhibition: *Desert Photographs*, Castelli Graphics, New York; Arco Center for Visual Art, Los Angeles.

Group exhibitions: *Exposing: Photographic Definitions*, Los Angeles Institute of Contemporary Art (catalogue). *L.A. Photographs L.A.*, Santa Ana College, Santa Ana, Calif.

1977
Joins the faculty of the Photography Program in the School of Art at the California Institute of the Arts, Valencia. Continues to hold this position to date, although the program has been expanded to Photography and Media.

Group exhibitions: *Cityscape*, De Young Museum Downtown Center, San Francisco. *Desert Photographs*, Pitzer College, Claremont, Calif. *Miniature*, California State University, Los Angeles. *Several Diverse Photographic Views*, SF Camerawork, San Francisco.

1977–79
Group exhibition: *Los Angeles in the Seventies: Michael Asher, Michael Brewster, Guy de Cointet, Judy Fiskin, Lloyd Hamrol, Michael McMillen, Lorne Madsen, Eric Orr, Roland Reiss*, Fort Worth Art

Museum, Fort Worth, Tex.; Norton Gallery and School of Art, West Palm Beach, Fla.; Joslyn Art Museum, Omaha, Neb. (catalogue).

1978–79
Health issues require Fiskin to take a leave of absence from the California Institute of the Arts.

Has metal flanges attached to the shutter curtain of her 35 mm camera to create a square-format negative.

Creates More Stucco series, which she retires after its exhibition at the Otis Art Institute of Parsons School of Design, Los Angeles, in 1981.

1979
Is one of six photographers commissioned by the Art Museum and Galleries of California State University, Long Beach, to create a photographic survey of Long Beach, funded with a Photography Survey Grant from the National Endowment for the Arts, Washington, D.C., and by the California Arts Council.

Group exhibitions: *California in Colorado*, Center for Photographic Arts, Denver, Colo. *Judy Fiskin, Dennis Hilger, Don Peterson*, Ruth Schaffner Gallery, Los Angeles.

1979–84
Serves as associate dean of the School of Art, California Institute of the Arts.

1980
Completes Long Beach series.

Begins living with Jon Wiener.

Group exhibitions: *Joe Deal, Judy Fiskin, Anthony Hernandez, Kenneth McGowan, Grant Mudford, Leland Rice: Long Beach, A Photography Survey*, Art Museum and Galleries, California State University, Long Beach (catalogue). *Landscape Images: Recent Photographs by Linda Connor, Judy Fiskin, and Ruth Thorne-Thomsen*, La Jolla Museum of Contemporary Art, La Jolla, Calif. (catalogue).

1981
Solo exhibitions: *Long Beach*, Los Angeles Institute of Contemporary Art. *More Stucco*, Otis Art Institute of Parsons School of Design, Los Angeles.

Group exhibitions: *California: The State of the Landscape (1872–1981)*, Newport Harbor Art Museum, Newport Beach, Calif.; Santa Barbara Museum of Art, Santa Barbara, Calif. (catalogue). *Four California Views*, Oakland Museum, Oakland, Calif. *Locations: Works by Richard Bennett Bell, Joe Fay, Judy Fiskin, Anthony Friedkin, Steve Kahn, Robert Glenn Ketchum, Karla Klarin, Robert Landau, Peter Liashkov, Michael C. McMillen, Gifford Myers, Pierre Picot, Astrid Preston, Roland Reiss, Leland Rice, Sandra Rubin, Judy Simonian, Wade Saunders, Barbara Thomason, Bob Yarber*, California State College, San Bernardino (catalogue).

1982
Begins Dingbat series, on which she will work for two years.

Solo exhibition: *Dingbat*, Newspace, Los Angeles.

Group exhibitions: *New Accessions*, Museum of Fine Arts, Houston, Tex. *New Images: Los Angeles Basin and San Francisco Bay Area*, San Francisco International Airport.

1983
Begins Some Aesthetic Decisions series, on which she will work for two years.

Solo exhibition: *Dingbat*, Paper Architecture, Minneapolis, Minn., sponsored by Film in the Cities.

Group exhibition: *L.A. Seen*, University Art Galleries, University of Southern California, Los Angeles.

1984
Solo exhibition: *Some Aesthetic Decisions*, Newspace, Los Angeles.

Group exhibitions: *Exposed and Developed: Photography Sponsored by the National Endowment for the Arts*, National Museum of American Art, Smithsonian Institution, Washington, D.C. (catalogue). *The Implied Performance*, California State University, Northridge. *L.A. and the Palm Tree: Image of a City*, Arco Center for Visual Art, Los Angeles. *Olympiad: Summer '84*, Koplin Gallery, Los Angeles. *Process/Strategy/Evolution: Shifts in Perception over Time*, Rochester Institute of Technology, Rochester, N.Y.

1984–86
Moves to New York for two years, taking a leave of absence from the California Institute of the Arts. Works with a New York sculptor to

design the frame that becomes an integral part of the presentation of her photographs.

Begins My Trip to New York series, on which she works for two years.

1985
A trip to New Orleans produces negatives that she does not print until 2006.

Solo exhibition: *New Work*, Malinda Wyatt Gallery, New York.

Group exhibition: *On View: Judy Fiskin, Janet Pihlblad, Lance Rutlege*, New Museum, New York.

1986
Makes first image in what will become Jersey Shore series.

Receives Reva and David Logan Grant in support of New Writing on Photography, administered by the Photographic Resource Center at Boston University, Mass.

Solo exhibition: *My Trip to New York*, Newspace, Los Angeles.

Group exhibitions: *Gentlemen's Choice*, Woman's Building, Los Angeles. *A Southern California Collection*, Cirrus Gallery, Los Angeles.

1986–88
Group exhibition: *A Visible Order*, curated by Renee Riccardo and Paul Laster, Lieberman & Saul, New York; Gallery 400, University of Illinois, Chicago; Otis Art Institute of Parsons School of Design, Los Angeles.

1987
Marries Jon Wiener.

Solo exhibition: *My Trip to New York*, Mount St. Mary's College, Los Angeles.

Group exhibitions: *Intimate Narratives*, Fresno City College, Fresno, Calif. Lorence-Monk Gallery, New York. *Through the Lens: 40 Years of Photography*, Fresno Arts Center and Museum, Fresno, Calif. *UCI Collects*, University of California, Irvine.

1988
Returns to New York for six months and completes Jersey Shore series.

Creates Portraits of Furniture series and New Architecture series.

Solo exhibition: *Survey, 1973–1988*, Newspace, Los Angeles.

Group exhibitions: *Group Material: Democracy*, DIA Art Foundation, New York. *Houses*, Home Savings and Loan, Los Angeles. *Suburban Visions*, Muckenthaler Cultural Center, Fullerton, Calif.

1989
Guest teaches a course on photography during the spring quarter at the University of California, Los Angeles.

Group exhibitions: *Contemporary American Photography*, University of Colorado, Colorado Springs. *Framing Four Decades: The University Art Museum Celebrates the Collections 1949–1989*, University Art Museum, California State University, Long Beach. *Photographs from the Permanent Collection*, Newport Harbor Art Museum, Newport Beach, Calif. *Poetic Objectives*, Curt Marcus Gallery, New York. *Remaking L.A.*, University of California, Los Angeles. *Stated as Fact: Photographic Documents of New Jersey*, New Jersey State Museum, Trenton (catalogue).

1990
Creates Some Art series.

Receives Individual Artist's Grant in Photography from the National Endowment for the Arts, Washington, D.C.

Solo exhibition: *Recent Work*, The Drawing Room, Tucson, Ariz.

Group exhibitions: *Encyclopedics: Theresa Bramlett, Judy Fiskin, Nicholas Rule*, Real Art Ways, Hartford, Conn. *Home*, Asher-Faure Gallery, Los Angeles (catalogue). *Perspectives on Place: Attitudes toward the Built Environment*, San Diego State University, San Diego, Calif. *Racing Thoughts*, Tom Solomon's Garage, Los Angeles. *Spirit of Our Time*, Contemporary Arts Forum, Santa Barbara, Calif.

1990–92
Health issues once again require Fiskin to take a leave of absence from the California Institute of the Arts.

1991
Solo exhibition: *Some Art*, Curt Marcus Gallery, New York; Asher-Faure Gallery, Los Angeles.

Group exhibitions: *California Cityscapes*, San Diego Museum of Art, San Diego, Calif. (catalogue). Curt Marcus Gallery, New York. *Death as a Creative Force*, Guggenheim Gallery, Chapman College, Orange, Calif. Laura Carpenter Fine Arts, Santa Fe, N.M. *The Legacy of Karl Blossfeldt*, Jan Turner Gallery, Los Angeles. *Photographing Los Angeles Architecture*, Turner/Krull Gallery, Los Angeles. *Present Picture*, fiction/non-fiction, New York. *Windows on AIDS*, Armory Center for the Arts, Pasadena, Calif.

1991–92
Group exhibition: *Typologies: Nine Contemporary Photographers*, Newport Harbor Art Museum, Newport Beach, Calif.; Akron Art Museum, Akron, Ohio; Corcoran Gallery of Art, Washington, D.C.; San Francisco Museum of Modern Art (catalogue).

1991–93
Group exhibition: *The Encompassing Eye: Photography as Drawing*, University of Akron, Akron, Ohio; Laguna Art Museum, Laguna Beach, Calif.; Lehman College Art Gallery, Bronx, N.Y.; Marsh Gallery, University of Richmond, Richmond, Va.; Museum of Contemporary Photography, Columbia College, Chicago.

1992
Begins More Art series, on which she will work for three years.

Solo exhibitions: *Judy Fiskin: Some Photographs, 1973–1992*, Museum of Contemporary Art, Los Angeles (artist's book). *Some Art and Some Furniture: Photographs by Judy Fiskin*, Birmingham Museum of Art, Birmingham, Ala.; Center for Creative Photography, University of Arizona, Tucson (catalogue).

Group exhibitions: *The Magic Object*, Los Angeles County Museum of Art. *The Naturalist Gathers*, curated by Douglas Blau, Stein/Gladstone Gallery, New York. *Passages*, Rena Bransten Gallery, San Francisco.

1992–94
Group exhibition: *Special Collections: The Photographic Order from Pop to Now*, International Center of Photography, New York; Fondation Deutsche, Lausanne, Switzerland; Mary & Leigh Block Gallery, Northwestern University, Evanston, Ill.; Arizona State University Art Museum, Tempe; The Chrysler Museum, Norfolk, Va.; Bass Museum of Art, Miami, Fla.; The Museums at Stony Brook, Stony Brook, N.Y.; Vancouver Art Gallery, Vancouver, Canada; Friends of Photography, Ansel Adams Center, San Francisco; Sheldon Memorial Art Gallery, Lincoln, Neb. (catalogue).

1993
Group exhibitions: *A.R.T. Press: An Exhibition*, Works Gallery, Newport Beach, Calif. Curt Marcus Gallery, New York. *Fragments and Form: Conjunctions in the Permanent Collection*, Museum of Contemporary Art, Los Angeles. *Inadvertently*, Asher-Faure Gallery, Los Angeles. *The Integrity of Structure*, The Works Gallery South, Costa Mesa, Calif. *L.A. Stories*, Jack Rutberg Fine Arts, Los Angeles. *On Paper: Vija Celmins, Judy Fiskin, Agnes Martin, Ellen Phelan*, Asher-Faure Gallery, Los Angeles.

1994
Begins experimenting with video.

Solo exhibitions: *More Art*, Patricia Faure Gallery, Santa Monica, Calif. *New Photographs*, Curt Marcus Gallery, New York.

Group exhibitions: *Here*, Quint Gallery, Mission Hills, Calif. *Love in the Ruins: Art and the Inspiration of L.A.*, Long Beach Museum of Art, Long Beach, Calif. (catalogue). *Southern California: The Conceptual Landscape*, Madison Art Center, Madison, Wis. *The World of Tomorrow*, curated by Douglas Blau, Tom Solomon's Garage, Los Angeles.

1994–96
Group exhibition: *After Art: Rethinking 150 Years of Photography, Selections from the Joseph and Elaine Monsen Collection*, Henry Art Gallery, University of Washington, Seattle; Friends of Photography, Ansel Adams Center, San Francisco; Portland Art Museum, Portland, Maine (catalogue).

1995
Receives Distinguished Career in Photography Award from the Los Angeles Center for Photographic Studies.

Group exhibitions: *Flowers*, Boritzer Gray Gallery, Los Angeles. *In the Field: Landscape in Recent Photography*, Margo Leavin Gallery, Los Angeles. *Landscapes: A Concept*, California College of Arts and Crafts, Oakland. *Object and Image*, Newport Harbor Art Museum, Newport Beach, Calif.

1996
Group exhibitions: *Long Beach Odyssey: Joe Deal, Judy Fiskin, Anthony Hernandez, Kenneth McGowan, Grant Mudford, Leland Rice (A Photographic Survey)*, University Art Museum, California State University, Long Beach. *Portraits of Interiors*, Studio La Citta, Verona, Italy; Galerie Blancpain Stepczynski, Geneva, Switzerland.

1997

Completes the video *Diary of a Midlife Crisis*, which is screened over the course of the next year at the Museum of Contemporary Art, Los Angeles; San Francisco International Film Festival (wins Silver Spire Award); WorldFest-Houston International Film Festival, Houston, Tex. (wins Bronze Award); Bonn Videonale, Bonn, Germany; Kassel Film and Video Fest, Kassel, Germany; Atlanta Film and Video Festival, Atlanta, Ga.; Brisbane International Film Festival, Brisbane, Australia; L.A. Freewaves, Los Angeles; Canadian International Film and Video Fest, Toronto; Film Arts Festival of Independent Cinema, San Francisco; United States Super 8 Film and Digital Video Festival, Rutgers University, Camden, N.J.; Station KTOP, Pittsburg, Pa.; City of Oakland Public Television, Calif.; Station DUTV, Philadelphia, Pa.

Group exhibitions: *Inhabited Space*, Long Beach Museum of Art, Long Beach, Calif. *Last Chance for Eden: An Exhibition of California Architecture*, Danish Architecture Centre, Copenhagen, Denmark. *Portraits of Interiors*, Patricia Faure Gallery, Santa Monica, Calif.

1997–98

Group exhibition: *At the Threshold of the Visible: Minuscule and Small-Scale Art, 1964–1996*, Herbert F. Johnson Museum of Art, Cornell University, Ithaca, N.Y.; Meyerhoff Galleries, Maryland Institute of Art, Baltimore; Art Gallery of Toronto; Art Gallery of Windsor, Canada; Contemporary Arts Center of Virginia, Virginia Beach; Santa Monica Museum of Art, Santa Monica, Calif.; Edmonton Art Gallery, Edmonton, Canada (catalogue).

1998

Receives Los Angeles Printmaking Society Purchase Award from the Grunwald Center for the Graphic Arts, Armand Hammer Museum of Art and Cultural Center, Los Angeles.

1999

Group exhibition: *Images for an Age*, Center for Creative Photography, Tucson, Ariz.

1999–2000

Receives commission from the J. Paul Getty Museum to create the video *My Getty Center*, which is screened over the course of the next year at Impakt New Media Festival, Utrecht, Holland; WorldFest-Houston International Film Festival, Houston, Tex. (wins Silver Award); Berkeley Film and Video Festival, Berkeley, Calif. (wins Best of Festival Award); Columbus International Film and Video Festival, Columbus, Ohio (wins Bronze Award); United States Super 8 Film

and Digital Video Festival, Rutgers University, Camden, N.J.; YYZ Artists' Outlet, Toronto; Station Community 21, Columbus, Ohio.

2000

Invited to contribute lyrics for a CD track on *Songpoems by Twenty-One Contemporary Artists*, published by Art Issues Press, Los Angeles; excerpts from letters written to her by her father in 1964–65 are recorded in the style of an operatic aria for her track *Junior Year Abroad*.

Group exhibitions: *Departures: 11 Artists at the Getty*, J. Paul Getty Museum, Los Angeles (catalogue). *Exurbia*, curated by Shirley Irons, Gallery Luisotti, Santa Monica, Calif. *Made in California: Art, Image, and Identity, 1900–2000*, Los Angeles County Museum of Art (catalogue). *Ocean View*, California Museum of Photography, Riverside.

2001–2

Receives commission from LACMALab, Los Angeles County Museum of Art, to create the video installation *What We Think About When We Think About Ships*.

Group exhibition: *Seeing*, LACMALab, Los Angeles County Museum of Art.

2003–4

Completes the video *50 Ways to Set the Table*, which is screened over the course of the next year at the Museum of Modern Art, New York; New York Underground Film Festival; Berkeley Film and Video Festival, Berkeley, Calif. (wins Best of Festival Award); Cinematexas, Austin, Tex.; South by Southwest Festival, Austin, Tex.

2004

Solo exhibition: *50 Ways to Set the Table*, Angles Gallery, Santa Monica, Calif.

Group exhibition: *Adams and 21 Eves: Women Photographers from the Vault*, University Art Museum, California State University, Long Beach.

2004–6

Begins the process of completing editions of six prints for each of her photographs. Working together with printer Lane Barden, she reviews her negatives and contact sheets to explore the possibility of adding new images to her photographic oeuvre. The New Orleans series is printed in this context.

2005
Group exhibition: *The Great Outdoors*, Angles Gallery, Santa Monica, Calif.

2006
Completes the video *The End of Photography*, which is screened over the course of the next year at Rencontres Internationales Paris/Berlin, France and Germany; Kassel Film and Video Festival, Kassel, Germany; European Media Art Festival, Osnabruck, Germany; Antimatter Festival, Victoria, Canada; Berkeley Film and Video Festival, Berkeley, Calif. (wins Grand Festival Award); WorldFest-Houston International Film Festival, Houston, Tex.; Video Festival, Dallas, Tex.; Davis Film Festival, Davis, Calif.; Anthology Film Archives, New York; Hi/Lo Film Festival, San Francisco; United States Super 8 Film and Digital Video Festival, Rutgers University, Camden, N.J.

Group exhibitions: *Campari* (*This show was not sponsored by . . .*), Park Projects, Los Angeles. *Los Angeles 1955–1985: Naissance d'une capital artistique* [*Birth of an Art Capital*], Centre Pompidou, Paris (catalogue). *Photographs That I Love*, Patricia Faure Gallery, Santa Monica, Calif. *Photos and Phantasy: Selections from the Frederick R. Weisman Art Foundation*, Frederick R. Weisman Art Museum, Pepperdine University, Malibu, Calif. *Trees*, Gallery Luisotti, Santa Monica, Calif.

2007
Solo exhibition: *The End of Photography*, Angles Gallery, Santa Monica, Calif.

Group exhibitions: *house home*, Red Dot Gallery, West Palm Beach, Fla. *Imaging and Imagining California*, Orange County Museum of Art, Newport Beach, Calif. *Natural Geographic*, Norma Desmond Productions, Los Angeles. *Sound Art Limo*, curated by Holly Crawford, AC Institute, New York.

Video screening: *The End of Photography* in Amsterdam International Documentary Festival, Holland; J. Paul Getty Museum, Los Angeles (invitational screening); *Modeling the Photographic: The End(s) of Photography*, McDonough Museum of Art, Youngstown, Ohio.

2008
Group exhibitions: *Collecting Collections: Highlights from the Permanent Collection of the Museum of Contemporary Art, Los Angeles*, Museum of Contemporary Art, Los Angeles. *Index: Conceptualism in California from the Permanent Collection*,

Museum of Contemporary Art, Los Angeles. *Living Flowers: Ikebana and Contemporary Art*, Japanese American National Museum, Los Angeles (catalogue). *On the Ground in LA*, Carl Berg Gallery, Los Angeles. *This Side of Paradise: Body and Landscape in Los Angeles Photographs*, Huntington Library, Art Collections, and Botanical Gardens, San Marino, Calif. (catalogue).

Video screening: *The End of Photography*, Galeria Virgilio, São Paulo, Brazil; Saison Vidéo, Espace Croisé, Lille, France; Le Silo, Bétonsalon, Paris.

2009
Group exhibition: *Le Paradis, ou presque: Los Angeles (1865–2008)*, Musée Nicéphore Niépce, Chalon-sur-Saône, France.

Video screenings: *50 Ways to Set the Table*, Los Angeles County Museum of Art. *The End of Photography*, Los Angeles County Museum of Art.

2010
Creates the video *Guided Tour*, which is screened over the course of the next year at Antimatter Film Festival, Victoria, Canada; *Fractional Systems Garage Project II*, curated by John Baldessari, MAK Center, Los Angeles; Chicago Underground Film Festival.

Solo exhibition: *Guided Tour*, Angles Gallery, Los Angeles.

Group exhibitions: *The Artist's Museum*, Museum of Contemporary Art, Los Angeles. *Collection: MOCA's First Thirty Years*, Museum of Contemporary Art, Los Angeles. *The View from Here*, San Francisco Museum of Modern Art. *Vortexhibition Polyphonica*, Henry Art Gallery, University of Washington, Seattle.

2011
Group exhibitions: *In Focus: Los Angeles, 1945–1980*, J. Paul Getty Museum, Los Angeles. *Under the Big Black Sun: California Art, 1974–81*, Museum of Contemporary Art, Los Angeles; *Civic Virtue: The Impact of the Los Angeles Municipal Art Gallery and the Watts Towers Art Center*, Los Angeles Municipal Art Gallery, Barnsdall Park.

Video screenings: *The End of Photography*, Images Festival, Toronto. *Guided Tour*, Images Festival, Toronto.

2012 (forthcoming)
Group exhibition: *It Happened at Pomona: Art at the Edge of Los Angeles, 1969–1973, Part 3: At Pomona*, Pomona College Museum of Art, Claremont, Calif.

BIBLIOGRAPHY

EXHIBITION CATALOGUES AND OTHER BOOKS

1975

Impetus: The Creative Process. Exh. cat. Los Angeles, 1975.

Thirty-One Views of San Bernardino, edited by David Alexander and Richard Preston, poetry by Dick Barnes, photographs by Judy Fiskin. Claremont, Calif., 1975.

1976

Exposing: Photographic Definitions. Exh. cat. Century City, Calif., 1976.

1977

Los Angeles in the Seventies: Michael Asher, Michael Brewster, Guy de Cointet, Judy Fiskin, Lloyd Hamrol, Michael McMillen, Loren Madsen, Eric Orr, Roland Reiss, edited by Marge Goldwater. Exh. cat. Fort Worth, Tex., 1977: 10, 16–17.

1978

[California Institute of the Arts].*Collected Works.* Valencia, Calif., 1978: 18–19.

1980

Joe Deal, Judy Fiskin, Anthony Hernandez, Kenneth McGowan, Grant Mudford, Leland Rice: Long Beach, A Photographic Survey. Exh. cat., edited by Constance W. Glenn, with Jane K. Bledsoe. Long Beach, Calif., 1980: 18–27.

Landscape Images: Recent Photographs by Linda Connor, Judy Fiskin, and Ruth Thorne-Thomsen. Exh. cat. La Jolla, Calif., 1980.

1981

Locations: Works by Richard Bennett Bell, Joe Fay, Judy Fiskin, Anthony Friedkin, Steve Kahn, Robert Glenn Ketchum, Karla Klarin, Robert Landau, Peter Liashkov, Michael C. McMillen, Gifford Myers, Pierre Picot, Astrid Preston, Roland Reiss, Leland Rice, Sandra Rubin, Judy Simonian, Wade Saunders, Barbara Thomason, Bob Yarber. Exh. cat. San Bernardino, Calif., 1981: 20–21.

Turnbull, Betty. *California: The State of Landscape 1872–1981.* Exh. cat. Newport Beach, Calif., 1981: 89.

1984

Foresta, Merry Amanda. *Exposed and Developed: Photography Sponsored by the National Endowment for the Arts.* Washington, D.C., 1984: 58–59.

Hugunin, James R. "Hey Judy! Let's Went." In J.R. Hugunin, ed., *Frequently Rejected Essays.* Los Angeles, 1984: 28–37.

1988

Judy Fiskin, edited by William Bartman, interview by John Divola, essay by Christopher Knight. Beverly Hills, Calif., 1988. Interview reprinted in *Between Artists: Twelve Contemporary American Artists Interview Twelve Contemporary American Artists*, edited by Lucinda Barnes, Miyoshi Barosh, William S. Bartman, and Rodney Sappington. Los Angeles, 1996: 63–77.

1989

Bzdak, Michael, and Charles Stainback. *Stated as Fact: Photographic Documents of New Jersey.* Exh. cat. Trenton, N.J., 1989: 12–13.

1991

Freidus, Marc. *Typologies: Nine Contemporary Photographers.* Exh. cat. Newport Beach, Calif., 1991: 96–105.

Home: Richard Artschwager, Jonathan Borofsky, Scott Burton, Vija Celmins, Judy Fiskin, Robert Gober, Philip Guston, Roy Lichtenstein, Claes Oldenburg, Richard Phillips, Rona Pondick, Joel Shapiro and Gertrude Stein. Exh. cat. Los Angeles, 1991.

Stofflet, Mary. *California Cityscapes.* Exh. cat. San Diego, Calif., 1991: 21–22, 38–39.

1992

Fiskin, Judy. *Some Art and Some Furniture.* Exh. cat. Birmingham, Ala., 1992.

Fiskin, Judy. *Some More Art.* Los Angeles, 1992.

Fuller, Gregory. *Kitsch-Art: Wie Kitsch zur Kunst wird.* Cologne, Germany, 1992: 25, 27, 47.

Stainback, Charles. *Special Collections: The Photographic Order from Pop to Now.* Exh. cat. New York, 1992: 38–39.

1994

After Art: Rethinking 150 Years of Photography, Selections from the Joseph and Elaine Monsen Collection. Exh. cat. Seattle, Wash., 1994: 92.

Love in the Ruins: Art and the Inspiration of L.A. Exh. cat. Long Beach, Calif., 1994: 17.

1997

Rugoff, Ralph, and Susan Stewart. *At the Threshold of the Visible: Minuscule and Small-Scale Art, 1964–1996.* Exh. cat. New York, 1997: 62–64.

1999

Historically Speaking—UAM: 25 Years of Excellence. Exh. cat., edited by Constance W. Glenn. Long Beach, Calif., 1999: 31.

Johnstone, Mark. *Contemporary Art in Southern California.* Sydney, Australia, 1999: 68–71.

2000

Barron, Stephanie, Sheri Bernstein, and Ilene Susan Fort. *Made in California: Art, Image, and Identity, 1900–2000.* Exh. cat. Los Angeles, 2000: 244.

Lyons, Lisa. *Departures: 11 Artists at the Getty.* Exh. cat. Los Angeles, 2000: 24–27.

2005

Rice, Mark. *Through the Lens of the City: NEA Photography Surveys of the 1970s.* Jackson, Miss., 2005: 158, 165–68, 192, 194.

2006

Los Angeles, 1955–1985: Birth of an Art Capital, edited by Catherine Grenier. Exh. cat. Paris, 2006: 251, 290–91.

2008

This Is Not To Be Looked At: Highlights from the Permanent Collection of the Museum of Contemporary Art, Los Angeles. Los Angeles, 2008: 98–99.

Watts, Jennifer A., and Claudia Bohn-Spector. *This Side of Paradise: Body and Landscape in Los Angeles Photographs.* Exh. cat. San Marino, Calif., and New York, 2008: 95.

2009

Higa, Karin. *Living Flowers: Ikebana and Contemporary Art.* Exh. cat. Los Angeles, 2009: 44–45.

ARTICLES AND REVIEWS

1973

Wilson, William. "Inaugural Shows at Woman's Building." *Los Angeles Times,* December 10, 1973.

1974

Mautner, Robert. "Photography 1974—Added Dimension." *Artweek* 5, no. 7 (February 16, 1974): 11–12.

1975

Seldis, Henry J. "The Creative Process in Words and Pictures." *Los Angeles Times,* November 16, 1975.

1976

Hazlitt, Gordon. "Verbal Intentions, Visual Results." *Artnews* 75, no. 1 (January 1976): 66–68.

Muchnic, Suzanne. "Exploratory Photographic Visions." *Artweek* 7, no. 40 (November 20, 1976): 1, 12.

Wilson, William. "Sculpture with a Poetic Fiber." *Los Angeles Times,* August 16, 1976.

_____. "Photography: Looking for Itself through the Lens." *Los Angeles Times,* November 7, 1976.

1977

Fisher, Hal. "Southern California Sampling." *Artweek* 8, no. 23 (June 16, 1977): 11–12.

Kutner, Janet. "Clear Meanings Evoke Response." *Dallas Morning News,* October 10, 1977.

_____. "Dallas/Fort Worth: Capricious Places." *Artnews* 76, no. 10 (December 1977): 102–6.

Nuckols, Carol. "Bricks, Sandbags, 'Crickets' Utilized in Art Museum Show." *Fort Worth Star-Telegram*, October 9, 1977.

Ross, Lee. "Artists Depict California Scene." *Shorthorn*, October 9, 1977.

1979

Wilson, William. "Art Walk: A Critical Guide to the Galleries." *Los Angeles Times*, January 19, 1979.

1980

Johnstone, Mark. "A Subjective View of Long Beach." *Artweek* 11, no. 40 (November 29, 1980): 11.

Oak, Winifred. "Graduate to a New Level of Understanding: University Art Galleries." *Orange Coast Magazine,* December 1980: 138–40.

Wigginton, Mark. "Long Beach Images: Art and Archives." *Long Beach Independent Press Telegram*, November 10, 1980.

1981

Bowles, Demetra. "Landscapes and Mindscapes." *Artweek* 12, no. 9 (March 7, 1981): 12.

Fox, Louis W. "Formalizing the City." *Artweek* 12, no. 35 (October 24, 1981): 4.

Johnstone, Mark. "Unfinished Business, *Long Beach: A Photographic Survey* at California State University, Long Beach." *Afterimage* 8, no. 7 (February 1981): 13.

Lau, Alberto. "Landscapes Near and Far." *Artweek* 12, no. 1 (January 10, 1981): 12.

1982

Armstrong, Richard. "Judy Fiskin, 'Long Beach Series,' Los Angeles Institute of Contemporary Art, and 'More Stucco,' Otis-Parsons Art Gallery." *Artforum* 20, no. 9 (May 1982): 90–91.

Berland, Dinah. " 'Dingbats' Find a Place in Art." *Los Angeles Times*, December 19, 1982.

Danieli, Fidel. "Judy Fiskin at LAICA, Los Angeles." *Images & Issues* 2, no. 4 (Spring 1982): 92.

Knight, Christopher. "She's Not a Dingbat, That's What She Shoots: Fiskin's Witty Photos Spotlight L.A. Apartment Buildings." *Los Angeles Herald Examiner*, December 15, 1982.

———. "Art '82." *Los Angeles Herald Examiner*, December 26, 1982.

Muchnic, Suzanne. "The Galleries." *Los Angeles Times*, December 31, 1982.

1983

Brumfield, John. "On Meaning and Significance." *Journal: A Contemporary Art Magazine* 35, no. 4 (Winter 1983): 43–48.

Clothier, Peter. "Judy Fiskin at Newspace." *Art in America* 71, no. 4 (April 1983): 189.

1984

Armstrong, Richard. "Judy Fiskin's Photographs." *Journal: Southern California Art Magazine*, no. 24 (September/October 1979): 27. Reprinted in *Journal: A Contemporary Art Magazine* 4, no. 40 (Fall 1984): 31–32.

Pincus, Robert L. "The Galleries." *Los Angeles Times*, November 16, 1984.

Relyea, Lane. "Pick of the Week." *L.A. Weekly*, November 23–29, 1984: 117.

1985

McDarrah, Fred. "Voice Centerfold: Photo." *Village Voice*, March 5, 1985: 73.

1986

Muchnic, Suzanne. "The Art Galleries." *Los Angeles Times*, December 12, 1986.

Tanney, Kathy. "Individualism Begins at Home." *Artweek* 17, no. 44 (December 27, 1986): 12.

1987

Cameron, Dan. "Group Show, Lorence-Monk." *Flash Art*, no. 133 (April 1987): 91–92.

Cohrs, Timothy. "Group Show, Lorence-Monk." *Arts Magazine* 61, no. 7 (March 1987): 111.

Hale, David. "Photo Exhibit Covers the Real and Surreal." *Fresno Bee*, May 17, 1987.

1988

Berland, Dinah. "Judy Fiskin, Newspace Gallery, Hollywood." *Artscene* 8, no. 4 (December 1988): 31–32.

Curtis, Cathy. "'Suburban Visions, Middle-Class Dreams' Opens Centennial Series." *Los Angeles Times*, Orange County edition, July 25, 1988.

Hoffman, Magdalena. "Gallery: The Photographic Eye." *Southern California House and Garden*, November 1988: 32–40.

Irmas, Deborah. "The Changing Ideal: New Models for Contemporary Photography." *SF Camerawork Quarterly* 15, no. 1 (Spring 1988): 7–11.

McKenna, Kristine. "The Galleries." *Los Angeles Times*, December 9, 1988.

1989

Gerstler, Amy. "Judy Fiskin at Newspace." *Art Issues*, no. 3 (April 1989): 25.

Pincus, Robert L. "Judy Fiskin: Some Questions of Aesthetics." *Visions Art Quarterly* 4, no. 1 (Winter 1989): 10–13.

Selwyn, Marc. "Judy Fiskin, Newspace, Los Angeles." *Flash Art*, no. 145 (March/April 1989): 117.

Spencer, Peter. "A Sweeping Look at New Jersey History." *Trenton Times*, December 18, 1989.

1990

Christensen, Judith. "Photo Exhibit Lends 'Perspective on Place.'" *San Diego Union-Tribune*, December 11, 1990.

Sutro, Dirk. "Exhibit Puts Design in Perspective Environment." *Los Angeles Times,* San Diego County edition, November 29, 1990.

Woodard, Josef. "Spirit of Our Time, Santa Barbara Contemporary Arts Forum." *Artweek* 21, no. 43 (December 20, 1990): 16–17.

1991

Curtis, Cathy. "Fiskin's Art Can Be Put in a Box." *Los Angeles Times*, Orange County edition, April 23, 1991.

_____. "The Galleries." *Los Angeles Times*, July 28, 1991.

_____. "One Picture Is Worth a Thousand Truths Discussion." *Los Angeles Times*, Orange County edition, April 9, 1991.

Gipe, Lawrence. "Judy Fiskin, Asher-Faure." *Flash Art* 24, no. 158 (May/June 1991): 142.

Hagen, Charles. "The Encompassing Eye: Photography as Drawing." *Aperture*, no. 125 (Fall 1991): 56–71, esp. 60.

Jarmusch, Ann. "Art Shows the Way We Were . . . and Are." *Los Angeles Tribune*, May 31, 1991.

Kandel, Susan. "The Tiny Photographs of Judy Fiskin." *Art Issues*, no. 16 (February/March 1991): 16–19, and cover.

Knight, Christopher. "Fiskin's Frame of Reference." *Los Angeles Times*, Orange County edition, February 5, 1991.

_____. "Different Worlds, Dramatic Visions." *Los Angeles Times*, May 23, 1991.

Myers, Terry R. "Judy Fiskin (Asher-Faure, Los Angeles; Curt Marcus)." *Arts Magazine* 65, no. 8 (April 1991): 82.

Ollman, Leah. "The New and Old California Contrasted." *Los Angeles Times*, May 31, 1991.

Pincus, Robert L. "In Focus: Repetition Dulls Exhibit's Impact." *San Diego Union-Tribune*, April 19, 1991.

_____. "Artists Achieve Urban Realism." *San Diego Union-Tribune*, May 31, 1991.

Raczka, Tony. "Things, Exactly as They Are: *Typologies: Nine Contemporary Photographers* at the Newport Harbor Art Museum." *Artweek* 22, no. 18 (May 9, 1991): 10.

Reed, Victoria. "A Promise Unfulfilled: *California Cityscapes* at the San Diego Museum of Art." *Artweek* 22, no. 27 (August 29, 1991): 10–11.

Rugoff, Ralph. "Hocus Focus: Behind the Contemporary Lens." *L.A. Weekly*, May 10–16, 1991: 41.

Schottlaender, Sherri. "Direct from Daddy's Den: Judy Fiskin at Asher-Faure." *Artweek* 22, no. 4 (January 31, 1991): 13.

Spector, Buzz. "Judy Fiskin, Asher-Faure Gallery." *Artforum* 29, no. 8 (April 1991): 132–33.

Wilson, William. "A Deadpan, Rich Look at the Bland." *Los Angeles Times*, April 9, 1991.

1992

Drohojowska, Hunter. "Let's Get Small." *Los Angeles Times*, November 15, 1992.

Goldberg, Vicki. "7,000 Pictures Are Better than One." *New York Times*, August 23, 1992.

Knaff, Devorah L. "Serious Art Disguised as Frivolity: Judy Fiskin's Photographs, at the Museum of Contemporary Art, Are Small but Intensely Powerful." *Press-Enterprise*, November 8, 1992.

Nicholson, Chuck. "Typologies: Nine Contemporary Photographers, Newport Harbor Art Museum." *New Art Examiner* 19, no. 5 (January 1992): 38–39.

1993

Curtis, Cathy. "A Salute to A.R.T. Press." *Los Angeles Times*, Orange County edition, May 13, 1993.

Drohojowska-Philp, Hunter. "The Pleasure Posture." *Art Issues*, no. 30 (November/December 1993): 20–23.

Pagel, David. "Whispers." *Los Angeles Times*, November 18, 1993.

Tager, Alisa. "Judy Fiskin." *Lapiz International Art Magazine* 11, no. 91 (January/February 1993): 72.

1994

Greene, David A. "Sight Unscene: The Virtual World of Judy Fiskin." *Los Angeles Reader*, November 4, 1994: 14.

Kandel, Susan. "Fiskin's Transcendental Photography." *Los Angeles Times*, October 27, 1994.

Knight, Christopher. "Year in Review." *Los Angeles Times*, December 25, 1994.

Pagel, David. "Taking a Glimpse into 'The World of Tomorrow.'" *Los Angeles Times*, February 24, 1994.

Paine, Janice T. "Out West: Madison Exhibit Surveys California Landscape." *Milwaukee Sentinel*, August 24, 1994.

Wright, Molly. "The Irony of Southern California: *The Conceptual Landscape* at the Madison Art Center." *Badger Herald*, September 1, 1994.

1995

Greene, David A. "P.L.A.N.: Photography Los Angeles Now." *Los Angeles Reader*, September 8, 1995: 17, 22.

Knight, Christopher. "Judy Fiskin." In *Last Chance for Eden: Selected Art Criticism by Christopher Knight, 1979–1994*, edited by Malin Wilson (Los Angeles, 1995): 56–58.

_____. "LACMA's 'P.L.A.N.' Isn't Your Standard Photo Show." *Los Angeles Times*, July 8, 1995.

Tumlir, Jan. "A Is for Archive." *Artweek* 26, no. 7 (July 1995): 12–14.

1996

Muchnic, Suzanne. "Push-Pull of Feminist Art." *Los Angeles Times*, April 21, 1996.

Roth, Charlene. "The Light under the Bushel." *Artweek* 27, no. 4 (April 1996): 12–13.

1998

Frank, Peter. "Gramercy Art Fair, 'Diary of a Midlife Crisis,' 'To Get Rid of Mystery,' Siqueiros-Koll Gallery Inaugural." *L.A. Weekly*, December 4–10, 1998: 147.

Pagel, David. "Best Bets." *Los Angeles Times*, December 3, 1998.

Schwabsky, Barry. "Super 8 Grows Up with a Festival of Its Own." *New York Times*, February 8, 1998.

Snyder, Jacob. "The 41st San Francisco Film Festival Coverage." *Film Threat Weekly*. www.filmthreat.com.

1999

Pagel, David. "Big Messages Come in Small Packages." *Los Angeles Times*, August 27, 1999.

2000

Cooper, Jacqueline. "Departures, Getty Center, Los Angeles." *New Art Examiner* 27, no. 10 (July/August 2000): 37.

Freudenheim, Susan. "The Getty's Link to the Living." *Los Angeles Times*, March 5, 2000.

Harvey, Doug. "Monumental Edibles at the Getty Contemporary." *L.A. Weekly*, March 8, 2000.

Intra, Giovana. "Departures, J. Paul Getty Museum at the Getty Center, Los Angeles." *Artext*, no. 70 (August/October 2000): 76–77.

Knight, Christopher. "Art Reviews: Between Rural and Suburban." *Los Angeles Times*, December 15, 2000.

Littlejohn, David. "The Gallery: Hilltop Invitational." *Wall Street Journal*, April 25, 2000.

Pagel, David. "Fresh Riffs on a Theme." *Los Angeles Times*, March 1, 2000.

2001

Bates, Dianne. "An Artistic Playground; 'Seeing' Uses Pieces from LACMA's Permanent Collection to Create a Show with Kids in Mind." *Los Angeles Times*, November 29, 2001.

Myers, Holly. "This Show Is Not Just Kids' Stuff; LACMALab's 'Seeing' Proves to Be a Creative Exhibition for Children that Works for Adults." *Los Angeles Times*, December 19, 2001.

2004

Freeman, Tommy. "Judy Fiskin at Angles Gallery." *Artweek* 35, no. 3 (April 2004): 22.

Myers, Holly. "Around the Galleries: Set the Table? Let Us Count the Ways." *Los Angeles Times*, January 30, 2004.

Timberg, Scott. "Tangling with Technology? It's an Art." *Los Angeles Times*, December 19, 2004.

Treffinger, Stephen. "Serious about Settings in 26 Fraught Minutes." *New York Times*, March 11, 2004.

Tumlir, Jan. "Judy Fiskin, Angles Gallery." *Artforum* 42, no. 8 (April 2004): 165.

2006

Muchnic, Suzanne. "L.A.'s So Aujourd'hui." *Los Angeles Times*, February 26, 2006.

2007

Bedford, Christopher. "Judy Fiskin at Angles." *Art in America* 95, no. 9 (October 2007): 222–23.

"Judy Fiskin." *NY Arts* (September/October 2007). www.nyartsmagazine.com.

Pagel, David. "Around the Galleries: Farewell to an Art, to an Era." *Los Angeles Times*, April 13, 2007.

Tumlir, Jan. "Sci-Fi Historicism, Part Two: Desertshore." *Flash Art* 40, no. 254 (May/June 2007): 118–21.

2008

Leingre, Guillaume. "Love Film, Love Camera." *Le Silo Blogspot*. www.lesilo.blogspot.com.

2009

Drohojowska-Philp, Hunter. "Oral History Interview with Judy Fiskin, 2009 Nov. 9–23." *Smithsonian Archives of American Art*. www.aaa.si.edu.

2010

Knight, Christopher. "Around the Galleries; Kinship through Big Art." *Los Angeles Times*, March 12, 2010.

———. "An L.A. Assembly: MOCA Dips into Its Collection for a Show of Local Artists." *Los Angeles Times*, November 1, 2010.

Miles, Christopher. "Judy Fiskin at Angles Gallery." *L.A. Weekly*, April 1, 2010: 37.

Zellen, Jody. "Editorial Recommendation: Judy Fiskin at Angles Art Gallery, Culver City, California." *Visual Art Source* (April 2010). www.visualartsource.com.

ARTICLES BY JUDY FISKIN

"On 'TV Generations.'" *Journal: A Contemporary Art Magazine* 6, no. 46 (Winter 1987): 12–13.

"Borges, Stryker, Evans: The Sorrows of Representation." *Views: The Journal of Photography in New England* 9, no. 2, special supplement (Winter 1988): 2–6. Reprinted in *Multiple Views: Logan Grant Essays on Photography, 1983–89*, edited by Daniel P. Younger. Albuquerque, N.M., 1991: 247–69.

"Commentary: 'Scenes' of a Censorship Zone." *Los Angeles Times*, April 17, 1993.

"Trompe l'Oeil for Our Time." *Art Issues*, no. 40 (November/December 1995): 27–29.

"If I Ran the NEA" *Los Angeles Times*, March 1, 2009.

FISKIN PHOTOGRAPHS IN SELECTED PUBLICATIONS

L.A. Magazine (July 15, 1972): 16–20.

Los Angeles Institute for Contemporary Art Journal, no. 1 (June 1974): cover. Reproduction from Stucco series.

Morris, Jan. "L.A. Turnoff." *Rolling Stone Magazine*, no. 216 (July 1, 1976): 30. Eight reproductions from Stucco series.

Afterimage 8, no. 6 (January 1981): 31. Reproduction from Long Beach series.

Afterimage 10, no. 6 (January 1983): 23. Reproduction from Dingbat series.

Beach, John, and John Chase. "Stucco Boxes." *Arts and Architecture* 3, no. 3 (1984): 43–46, 80. Sixteen reproductions from Dingbat series.

Spectacle: A Field Journal from Los Angeles, no. 5/6 (Fall 1986): 43. Three reproductions from Stucco series.

Fiskin, Judy. "Dingbats, Los Angeles Box Apartment Houses from the 1950s–60s" *Stroll* 2, no. 2 (November 1986–January 1987): 20–21. Twenty-three reproductions from Dingbat series.

Zyzzyva IV, no. 4 (Winter 1988): 38–39. Two reproductions from Portraits of Furniture series.

Gerstler, Amy, and Alexis Smith. *Past Lives*. Santa Monica, Calif., 1989: 1. Reproduction from Portraits of Furniture series.

Fiskin, Judy. "Portraits of Furniture." *Paris Review* 31, no. 110 (Spring 1989): 61–73. Twelve reproductions from Portraits of Furniture series.

Oversight (Spring 1990): 20–21. Two reproductions from Jersey Shore series.

Fiskin, Judy. "My Trip to New York." *Offramp* 1, no. 3 (Fall 1990): 26–31. Five reproductions from My Trip to New York series.

Framework 4, no. 2 (1991): 23.

Los Angeles Times Magazine (September 5, 1993): cover.

Design Quarterly, no. 162 (Fall 1994): 9. Reproduction from Dingbat series.

Lingo: A Journal of the Arts, no. 4 (1995): 158–59. Two reproductions from Dingbat and New Architecture series.

Fiskin, Judy. "Home." *Art & Design* 11, no. 11/12 (November-December 1996): 62–69. Eight reproductions from various series.

Ilyn, Natalia. "Modernism and the Perfect." *Metropolis Magazine* (November 2002): 114. Four reproductions from Dingbat series.

Santa Monica Review 20, no. 2 (Fall 2008): cover. Reproduction from Stucco series.